IMAGES
of America

HAMDEN REVISITED

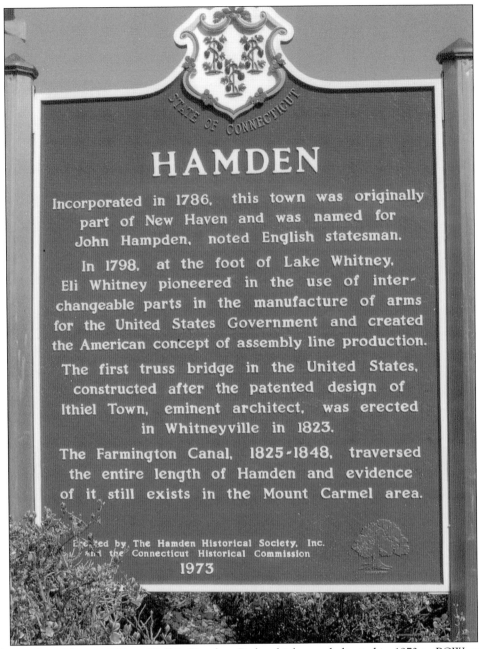

HAMDEN

Incorporated in 1786, this town was originally part of New Haven and was named for John Hampden, noted English statesman.

In 1798, at the foot of Lake Whitney, Eli Whitney pioneered in the use of inter-changeable parts in the manufacture of arms for the United States Government and created the American concept of assembly line production.

The first truss bridge in the United States, constructed after the patented design of Ithiel Town, eminent architect, was erected in Whitneyville in 1823.

The Farmington Canal, 1825-1848, traversed the entire length of Hamden and evidence of it still exists in the Mount Carmel area.

Erected by The Hamden Historical Society, Inc. and the Connecticut Historical Commission
1973

Across from Memorial Town Hall in Freedom Park, which was dedicated in 1973 to POWs and MIAs of US armed forces, there is a sign placed as part of America's bicentennial celebration. The words were written by Martha Becker, historian for Hamden and the town's historical society, chair of the Hamden Library Board, author, and member of the Hamden Bicentennial Commission. (Courtesy of John Carolla.)

ON THE COVER: The Day Spring Lodge built a new temple in 1933 where the old Centreville Trotting Park had been, situated between Whitney and Washington Avenues. (Courtesy of the Hamden Historical Society.)

IMAGES
of America

HAMDEN REVISITED

Hamden Historical Society

ARCADIA
PUBLISHING

Published by Arcadia Publishing
Charleston, South Carolina

Printed in the United States of America

Library of Congress Control Number: 2013949403

For all general information, please contact Arcadia Publishing:
Telephone 843-853-2070
Fax 843-853-0044
E-mail sales@arcadiapublishing.com
For customer service and orders:
Toll-Free 1-888-313-2665

Visit us on the Internet at www.arcadiapublishing.com

We dedicate this book to members of the Hamden Historical Society, past and present, who support preserving the past so that future generations can learn from and appreciate a time gone by, yet ever present.

CONTENTS

Acknowledgments 6

Introduction 7

1. The Century Begins 9

2. From 1929 to 1941 19

3. Hamden in World War II 43

4. The Mid-Century 51

5. The 1960s 71

6. The 1970s 89

7. The 1980s 99

8. The Century's End 111

ACKNOWLEDGMENTS

Most of the photographs in this volume are from the collections of the Hamden Historical Society, as preserved in the Hamden History Room of Miller Memorial Library. Collections represented here include those of Al Baines, the Bassett family, John Della Vecchia, the Eckels family, the Gilbert family, the Grandy family, the Greist family, the Hamden Arts Commission, the Hamden Chamber of Commerce, Joe McDermott, Carl Rennie, and Ray Sims Sr. Photographers whose work has been used include R. Paul Andersen, Burt Benham, Margaret E. Beschel, T.S. Bronson, Steve Buckingham, John Carolla, Tom Calamo, William B. Day, David L. Dunn, Jackey Gold, Leone Rice Grelle, Bob Hoodes, Leland Robinson, I.A. Sneiderman, and Arthur Talmadge.

We are grateful to Joe Pepe, the Hamden Historical Society's archivist, for his assistance in assembling and scanning photographs. Our thanks go out as well to the Hamden Chamber of Commerce, the Rotary Club of Hamden, the Hamden Arts Commission, and the Hamden Department of Elderly Services for allowing searches of their photograph collections. The staff at Brooksvale Park, the Friends of Brooksvale Park, and the Hamden Elks Lodge graciously lent images. Julie Hulten located photographs of Sleeping Giant State Park. Mayor Scott Jackson and his staff provided constant interest and encouragement. We also offer a salute to armed forces veterans who shared their memories along with their service images.

INTRODUCTION

The title of this volume, *Hamden Revisited*, not only conveys that it is a sequel to an earlier photographic essay, Images of America: *Hamden*, published in 2004, but that this further selection is another trip through a community's past, a history that every new visit rewards. That is the nature of the past; stories and images can be assembled to tell a new tale or an old one in a different way. That is what this book attempts to do. If, along the way, anyone who picks up this book indulges in some nostalgia because he or she recognizes their own faces, or those of family or friends, or perhaps familiar sights that have now disappeared in all but memory and old photographs, all the better.

Hamden was originally part of the New Haven colony, founded in 1638 by a Puritan group from England headed by Rev. John Davenport and Theophilus Eaton, who purchased a large tract of land from the local Quinnipiac Indians. Settlement in the area had begun sporadically in the 1730s, as farmers ventured northward for more and better land for their crops, and entrepreneurs took advantage of the area's many streams to create waterpower to run grist, saw, and cider mills as well as distilleries. It was not until after the Revolutionary War that Hamden was set off as a distinct town from New Haven in 1786. It became the location for early industrial villages, such as those of Eli Whitney, whose factory along Lake Whitney produced muskets for the government, and Elam Ives, whose facility along the Mill River specialized in carriage parts. Through the 19th century, the town developed slowly, remaining a collection of isolated hamlets separated by woods and fields, punctuated by collections of small factories, mines, and shops. Even modern transportation, in the form of the Farmington Canal in the 1820s, and the coming of the railroad in the 1840s, while linking the town to regional economies, still left the community relatively isolated. By the very end of the 19th century, however, things were beginning to change at a faster rate. Which brings us to the 20th century and the focus of this essay in images.

The 20th century has been called "the American Century" because it was when the United States came into its own and grew to be a dominant and formative force in the world. Hamden's history reflects that experience, writ small. At the beginning of the century, "the Land of the Sleeping Giant" was a sleepy place itself, a patchwork of small hamlets, largely rural and agricultural, with dirt lanes and orchards spread over the hills. But through world wars, industrialization, commercialization, the growth of suburbs, and the transportation and technological revolutions, the town grew from only a few thousand souls in 1900 to over 60,000, the size of a small city, by the time it entered the 21st century. The town evolved socially, economically, and culturally; sometimes smoothly, sometimes painfully. Through those changes, Hamden has achieved its own identity through its sites, through its creations, and, most of all, through its people. The images assembled here illuminate those sites, those creations, and its people, their continuities and their changes, over that long century.

The chapters assemble images and information by eras and decades. In the first three decades of the century, Hamden began the slow transition into modernity with the growth of industries

and civic organizations while still retaining the overall character of a farming community. The coming of the World War I, and then World War II, however, brought trial, tragedy, and an international perspective for Americans and for the people of Hamden. As a result of World War II, the United States became an industrial juggernaut, and the return of its soldiers, male and female, brought a changed society. Suburban, commercial culture developed and took firm hold mid-century. Changes in Hamden during the third quarter of the century—racially, socially, and ideologically—reflected unrest in the country at large, but through it all, the town's organizations and services continued to develop in the hands of changing forms of local government. The closing decades of the century saw economies shifting away from traditional and defense-related manufacturing to more diversified technologies. At century's end, the people of Hamden faced the challenges and opportunities of a new era through traditional rituals of community: voluntary, civic, and professional groups; benevolent societies; and time-tested means such as potlucks and parades, festivals and fireworks, concerts and commemorations.

Finally, the significance of photographic essays such as this should not be merely nostalgic. It should not memorialize, like a time capsule, a lost way of life for which we pine. Certainly, such images confront us with how people in previous decades and centuries lived, thought, and defined community differently from us, and there are important lessons to take from new perspectives gained through the study of things past. However, a further, vital purpose of books such as this should be to inspire residents, organizations, and especially, leaders in government to work to preserve history in their communities while the material artifacts and living memories are still available. We cannot wait until it is too late—or worse, relegate our histories to a second-rate priority, maintaining an indifference for such issues in the face of the ever-changing present. When this happens, we all lose so much.

—Al Gorman, president of the Hamden Historical Society
Kenneth P. Minkema, Hamden municipal historian

One

THE CENTURY BEGINS

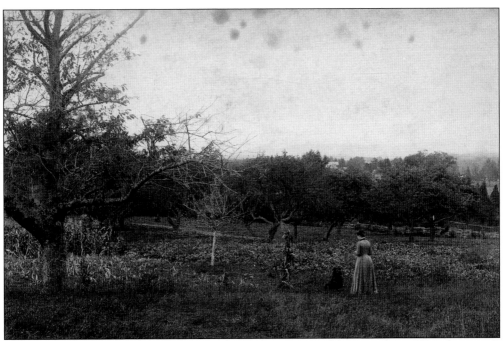

In the early 1900s, Hamden was largely rural with dairy, hay, and fruit tree farms. This photograph was taken from the Augur farm near Morris Street and looks northeast toward a section of Hamden called Whitneyville, established by inventor Eli Whitney in the late 18th century as the location for his factory. The Whitneyville Congregational Church (the present structure of which was built in 1840 and is in the National Register of Historic Places) can be seen in the distance. During the 20th century, Whitneyville transformed into a residential neighborhood when trolley lines were constructed from New Haven.

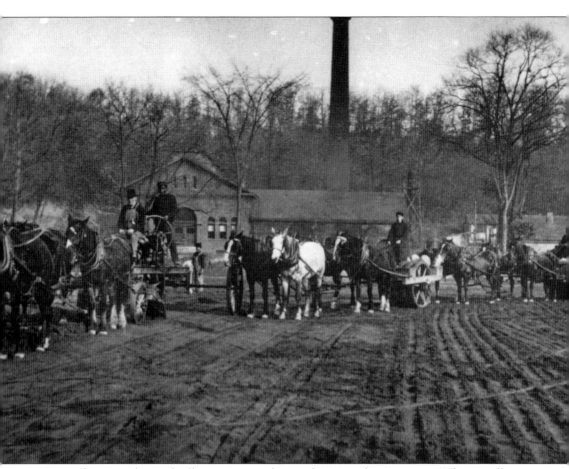

Horse-drawn graders and rollers are pictured around 1900 at the Armory in Whitneyville.

The teacher, pupils, and schoolhouse of the State Street Public School are shown in this early 1900s photograph.

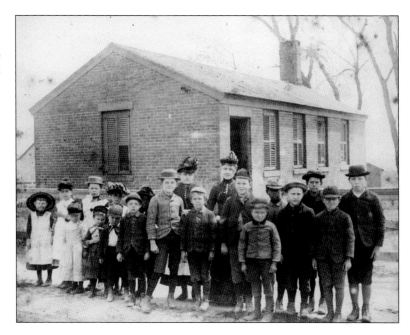

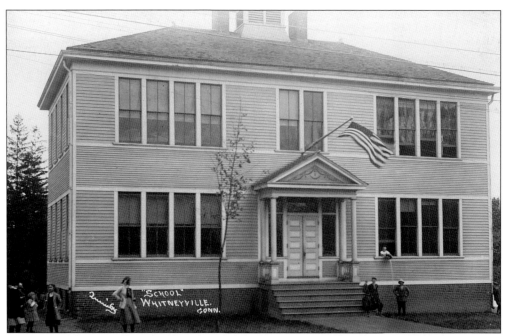

The 1902 Whitneyville School replaced the old two-room schoolhouse, which was located north of the Whitneyville Congregational Church. A few years after its construction, the school received a gift of 28 Norway maple trees from Frederick D. Grove, whose estate overlooked what was a barren and treeless schoolyard. The school's site is now part of Eli Whitney Park at Davis Street and Whitney Avenue.

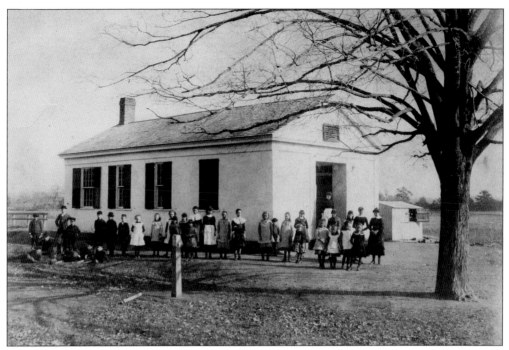

The schoolhouse in district no. 11, built around 1795, was originally located on the east side of Dixwell Avenue between Haig and Mathers Streets. The building was moved to the northeast corner of Alstrum and Arch Streets and converted into a residence. Teacher Hattie Warner Broadbent stands in the doorway.

Brockett Cottage sits atop the third mountain of Mount Carmel in 1900. Before it became a state park in the 1930s, the Sleeping Giant range had several cabins atop it, where local families would spend the summer months.

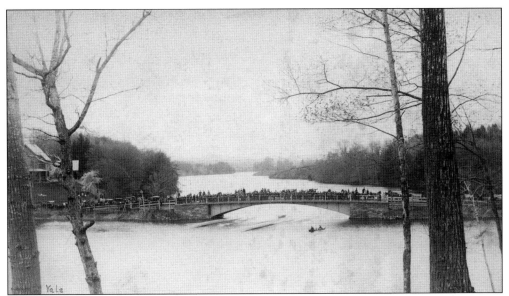

The Yale crew team races on Lake Whitney at the Davis Street Bridge around 1905.

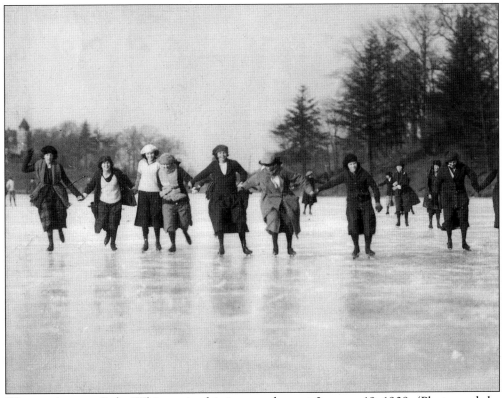

Women skate on Lake Whitney in this image taken on January 19, 1908. (Photograph by T.S. Bronson.)

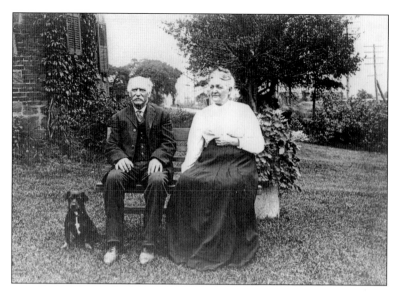

Charles Loyal Stevens and his wife, Susan Abigail (Ives) Stevens, are pictured on the lawn of their home at 2424 State Street in August 1908. The house, originally built by John Louis Mansfield in 1821, was constructed of stone and brick, which was rare in Hamden at that time. It was demolished in 1987.

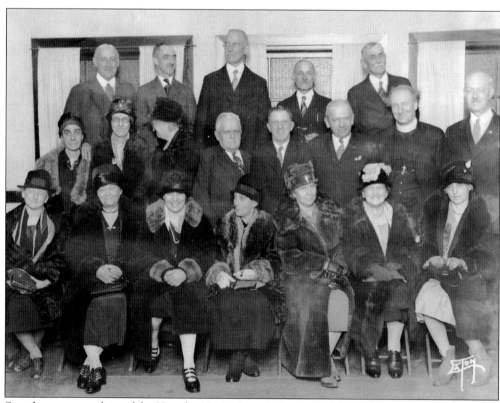

Seen here are members of the Hamden Civic Association in 1911. From left to right are (first row) Helen Potter, Elizabeth Hooker, Gladys Crook, Alice Remer, Evangeline Bassett, Mrs. A.J. Ralph, and Ella Bassett; (second row) Alice Warner, unidentified, Jennie Ives, Burton Potter, Floyd A. Beecher, Roger Bacon, Rev. George Cooley, and William Harris; (third row) Ellsworth Warner, Walter Bassett, Rev. W.G. Lathrop, and Manley Chester.

Pictured on Woodruff's Pond in the summer of 1911 are Lily Rose Elfe (left) and a Mrs. Sommerman, whose family lived on Spruce Bank Road. (Courtesy of Arthur R. Eckels.)

Margaret L. Keefe, a longtime teacher, principal, and superintendent of Hamden Schools, is seen here in 1911. The Pine Street School, built in 1921, was renamed in her honor.

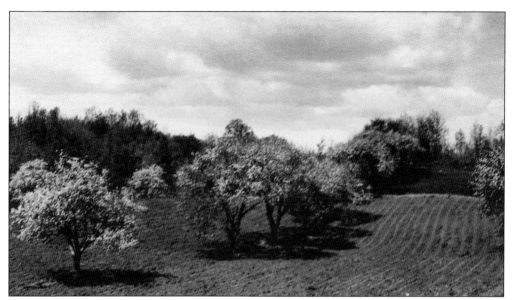

This is a 1912 photograph of Rufus Tyrell's farm on Shepard Avenue. (Courtesy of John Della Vecchia.)

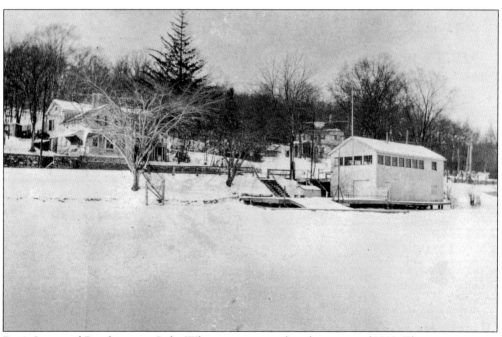

Day's Store and Boathouse on Lake Whitney is pictured in the winter of 1913. Three generations ran the business from 1839 to 1916. The store was moved to the west side of Whitney Avenue when the 1861 dam was constructed by the Lake Whitney Water Company, under the leadership of Eli Whitney II, and the lake waters rose. (Photograph by William B. Day.)

Leverett A. Bassett, born in 1895, wears his doughboy uniform about 1917. He died in 1958.

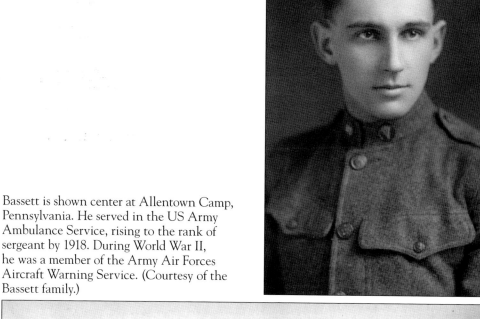

Bassett is shown center at Allentown Camp, Pennsylvania. He served in the US Army Ambulance Service, rising to the rank of sergeant by 1918. During World War II, he was a member of the Army Air Forces Aircraft Warning Service. (Courtesy of the Bassett family.)

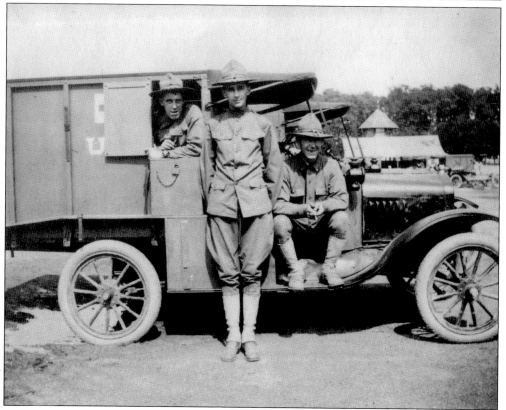

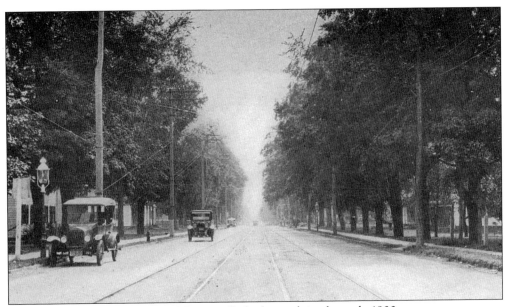

This view of Whitney Avenue in Centreville looks south in the early 1900s.

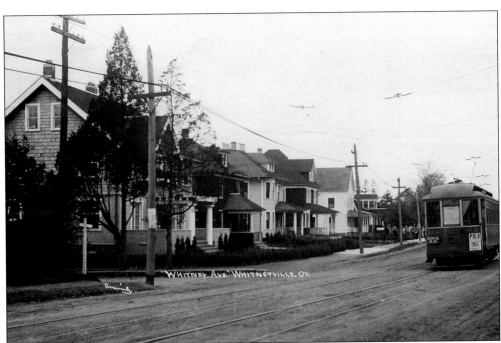

The running of the trolley line to Whitneyville in the early years of the 20th century allowed for more people to live outside of New Haven and commute. In the first decade of the century, a new neighborhood, the Cedars, arose to the west of the Whitneyville Church.

Two

FROM 1929 TO 1941

Dixwell and Whitney Avenues served as the main crossroads for Centreville, which was slow to develop until Whitney Avenue was paved and the trolley line reached the area from New Haven. A volunteer fire company was formed in 1908, and the Centreville school was built in 1918. A new town hall was constructed in 1924, and the older village landscape began to transform into a busy town center. This photograph was taken in 1925.

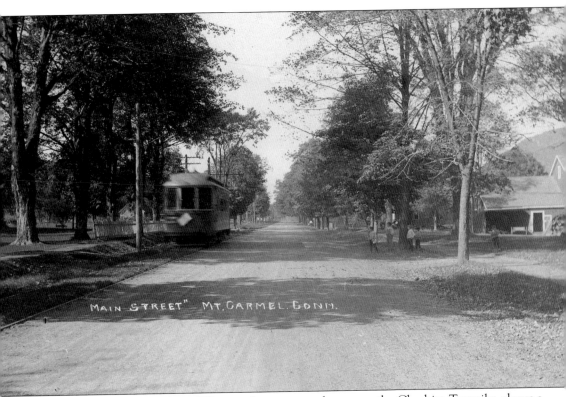

MAIN STREET" MT. CARMEL, CONN.

This view looking north on Whitney Avenue, once known as the Cheshire Turnpike, shows a trolley that served as mass transit in the first half of the 20th century.

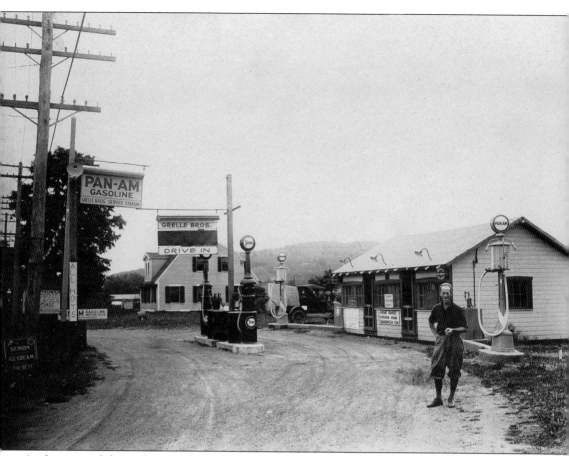

As the automobile revolutionized travel, the need for service stations grew. The Grelle Bros. Gas Station and Store was at 3800 Whitney Avenue about 1923. Currently, General Rental is located at the site. (Photograph by Leone Rice Grelle.)

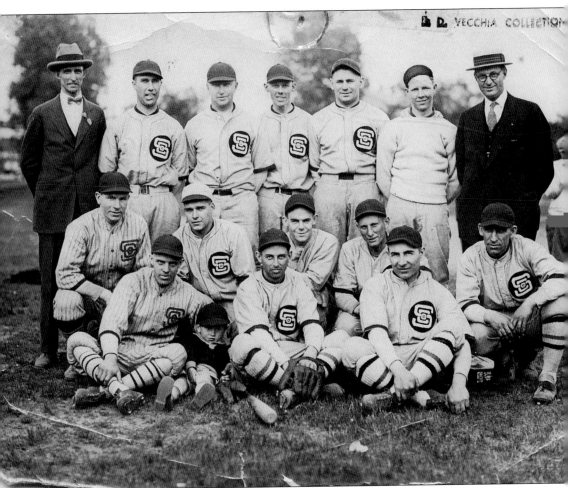

The Safety Car Baseball Team is pictured here in 1924. The Safety Car Heating and Lighting Company (later Safety Industries, Inc.) moved to Dixwell and Putnam Avenues in 1920 from New Jersey. The company made lamps and burners for railroads, lighting fixtures, electrical equipment, and air-conditioning units for boats. Its Entoleter Division manufactured centrifuge machines for processing grain.

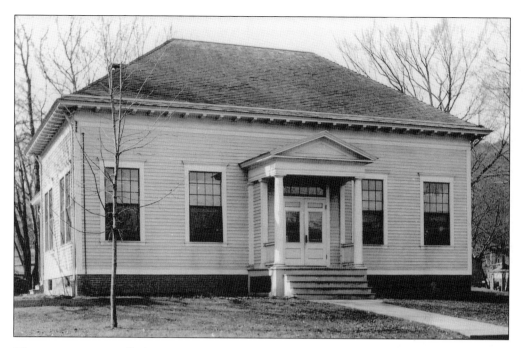

This structure, originally the Mount Carmel schoolhouse, which replaced the 1890 school structure across the street, was given to the Mount Carmel Library Association in the 1920s. The library closed when the Miller Memorial Central Library and Cultural Complex opened in 1980. The building was remodeled and housed business offices and the Ansonia Savings Bank at various times; now, it is home to the Irish Great Hunger Museum operated by Quinnipiac University.

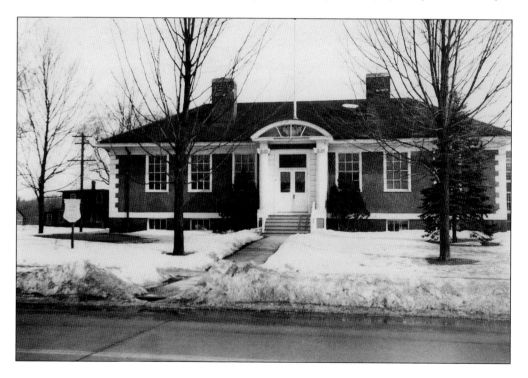

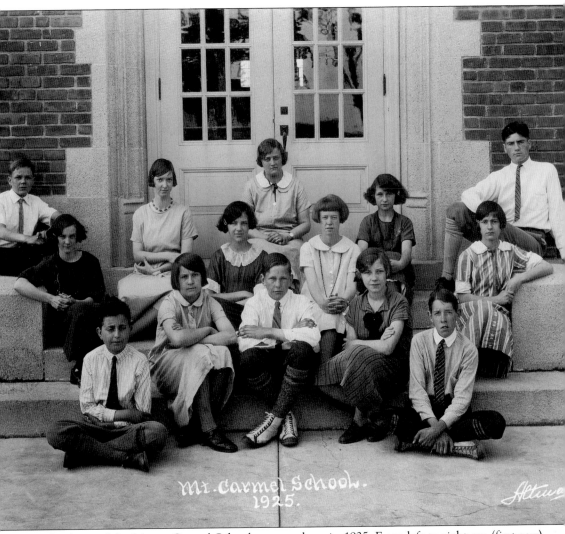

Students of the Mount Carmel School are seen here in 1925. From left to right are (first row) Philip Levine, Helen Clouse, Emil Strain, Lillian Officer, and Burton Lyman; (second row) Ethel Crosby, Ruth Summerman, Adeline Krott, Mary Petroski, and Edna Andrews; (third row) Ray Milum, Florence Trappe, Elvita Holmes (principal), and Frank Donahue.

Originally the Jared Bassett House (constructed 1819) on Old Dixwell Avenue, this building has had several reincarnations as a restaurant; for many years, it was the Colonial House.

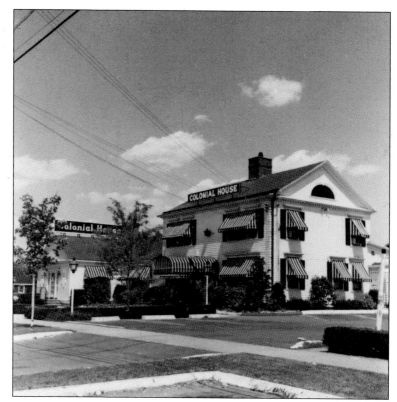

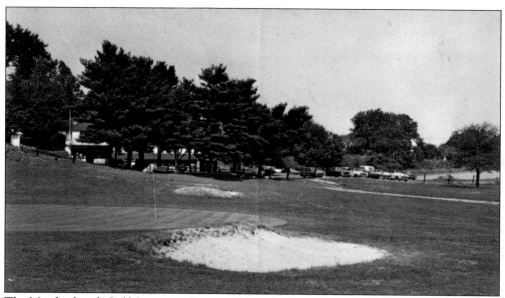

The Meadowbrook Golf Course in Centreville was laid out in 1924 on land that had once been a dairy farm belonging to H. Irving Todd. At the time, it was an 18-hole course; the first hole was a 213-yard par four, and the second was a 104-yard par three. The old dairy barn served as the clubhouse, and the upper floor was used for wedding receptions and dinners.

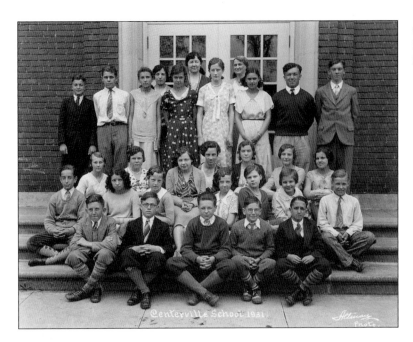

Centreville School is pictured here in 1931.

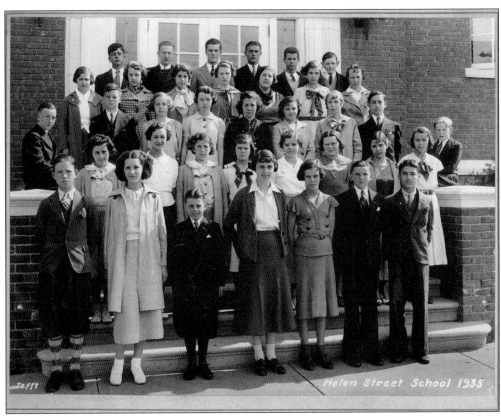

Anna Hines's class at Helen Street School is seen here in 1935. (Photograph by Arthur J. Tefft.)

Maj. A. Frederic Oberlin was an intelligence officer during World War I and a decorated war hero. He also was a charter member and commander of American Legion Hamden Post No. 88.

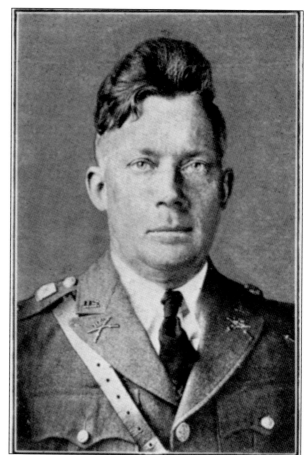

A new bridge on Davis Street over Lake Whitney was dedicated to the memory of Major Oberlin in June 1939; he had designed and supervised its construction in 1937 as assistant town engineer. It was the largest engineering structure ever built by the town, at a cost of $63,500. The Davis Street Bridge was replaced in 1993. The plaque commemorating Oberlin that originally was attached to the Davis Street Bridge is now on the Ithiel Town Bridge at the Eli Whitney Museum.

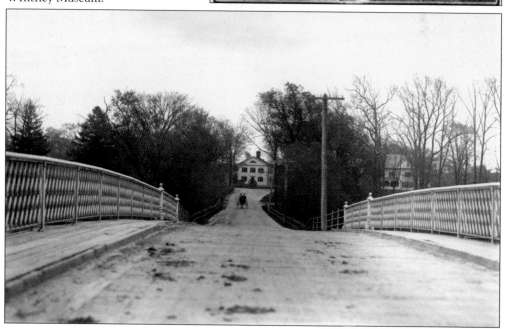

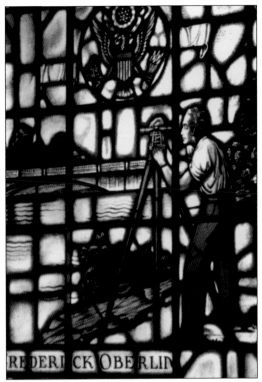

In Memorial Town Hall, the stained-glass memorial windows were dedicated to Frederic Oberlin's war service. Memorial Town Hall has since been placed in the National Register of Historic Places. The project to renovate the entire structure, including the fire department, and add a police station wing was completed in 2012.

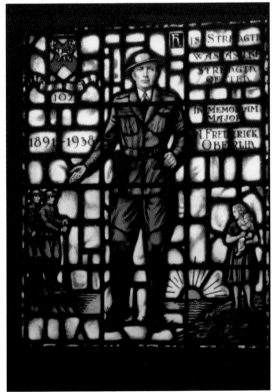

Another stained-glass window in Memorial Town Hall's rotunda recalls Oberlin's work as a surveyor and engineer.

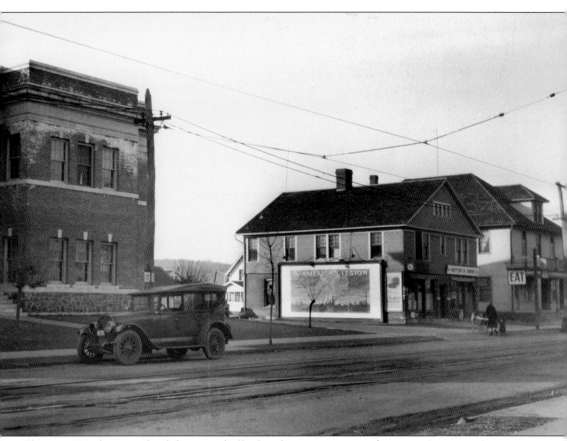

This c. 1926 photograph of the town hall's fire department wing shows an American Legion billboard on the side of Dalillo's Market.

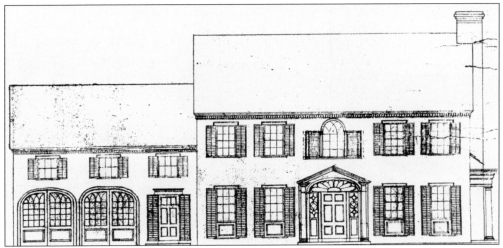

This 1929 sketch of the Walker House is by noted self-taught architect and Hamden resident Alice Washburn.

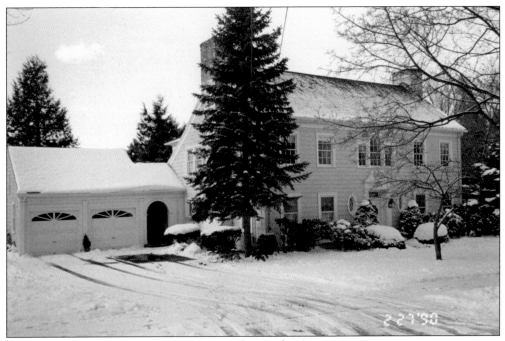

The Walker House is seen here, as it appeared around 1990.

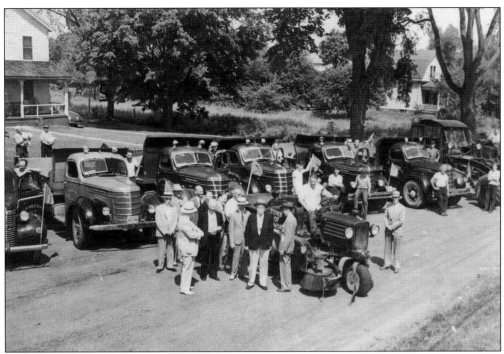

Public Works equipment is pictured on Old Dixwell Avenue. (Photograph by A. Talmadge.)

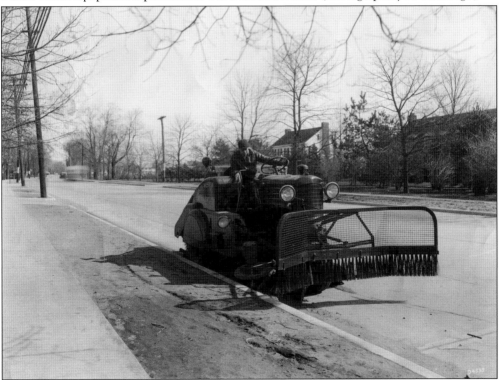

This street sweeper is being driven by Joseph Leggiero on Whitney Avenue between Glen Parkway and Santa Fe Road.

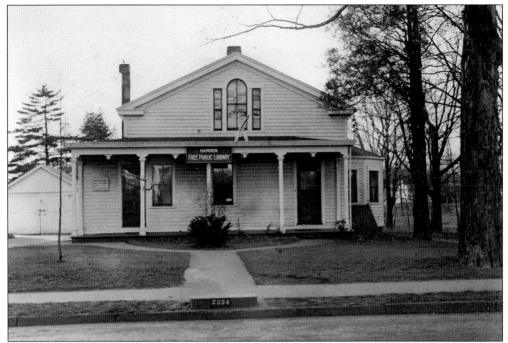

Built as part of the Rectory School about 1850, "the Cabin" was home of the school's rector, C.W. Everest. By the 1900s, it was the residence of Dr. Walter S. Lay, who became the town health officer in 1908. In 1916, the first telephone exchange for Hamden was located here; in 1931, the building became the home of Hamden's Free Public Library until 1952, when a new library opened at 2901 Dixwell Avenue.

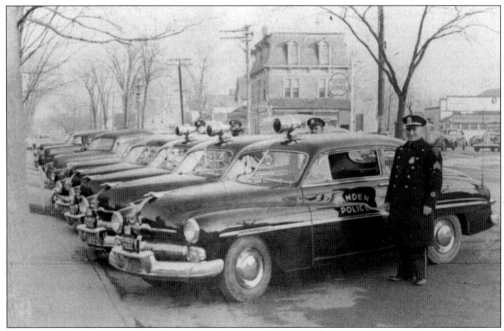

Police cruisers are pictured on Dixwell Avenue, representing the evolution of a professional police force during the early 20th century and replacing the traditional town constables.

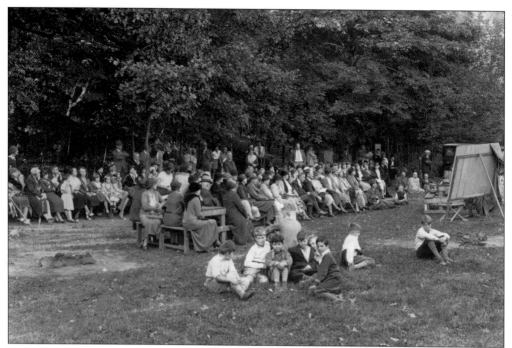

This picture was taken during the jubilee meeting of the Sleeping Giant Park Association on October 12, 1933. Attendees celebrated the purchase of the "Giant's head" and the closing of the quarry.

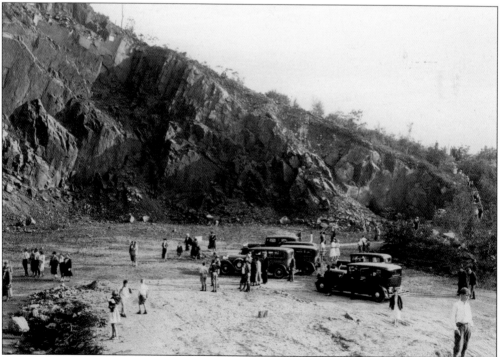

Pedestrians make their way down the new nature trail on the right to gather on the floor of the quarry.

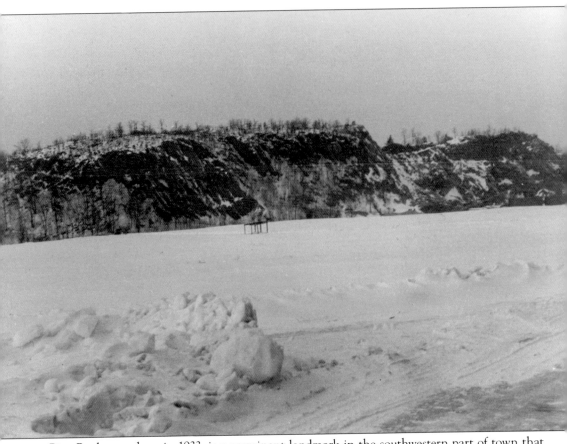

Pine Rock, seen here in 1933, is a prominent landmark in the southwestern part of town that once was a quarry. (Photograph by Philip Egan.)

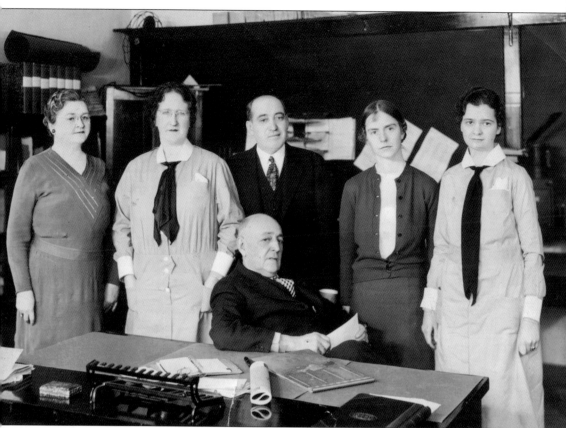

Hamden's first health staff is pictured here on February 2, 1935. They are, from left to right, (seated) town health officer George Joslin; (standing) clerk Mary Bulger, senior nurse Lillian B. Parker, school dentist Joseph M'Creegan, school physician Elizabeth Harrison, and nurse Blanche Crossley.

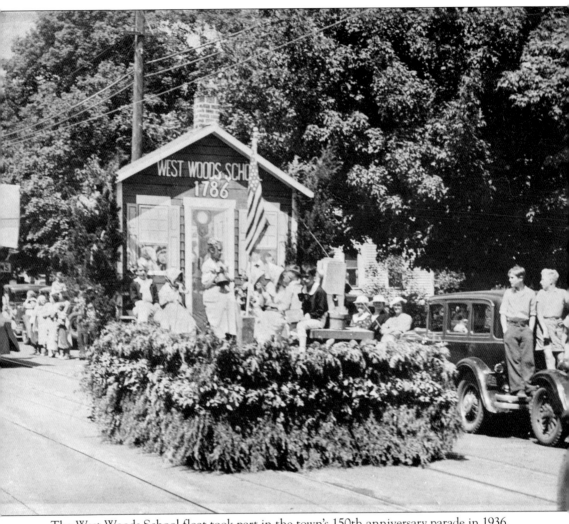

The West Woods School float took part in the town's 150th anniversary parade in 1936.

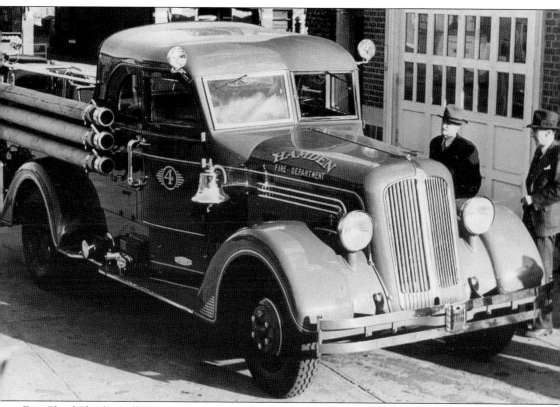

Fire Chief Charles Loller is among those receiving delivery of a 1938 Seagrave 600-GPM Canopy Club pumper.

Like nearly every other town in the country, Hamden had its own favorite recipes as proven by the cover of the *Whitneyville Women's Club Cookbook*, published in 1939.

In this c. 1940 photograph, taken at Dalillo's (not Dattilo's) Market in Centreville, are, from left to right, Sal, Tony, and August "Bob" Dalillo.

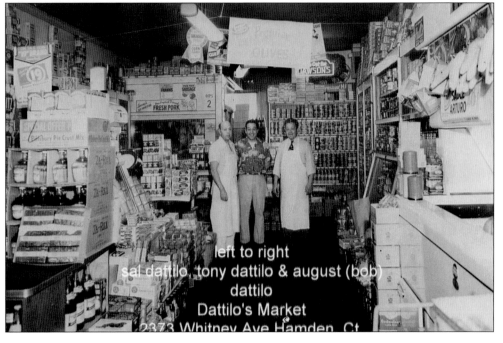

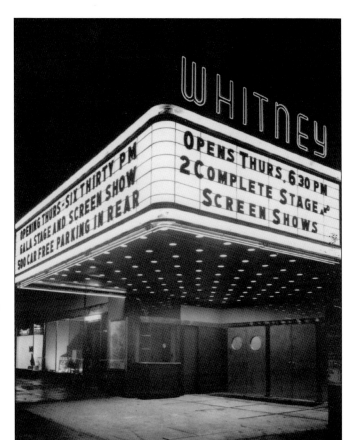

Located in Whitneyville, the Whitney Theater opened in 1940, featuring an Art Deco design that reflected the glamour of Hollywood. One of three neighborhood theaters in Hamden, the Whitneyville entertained generations of moviegoers until it closed in 1983.

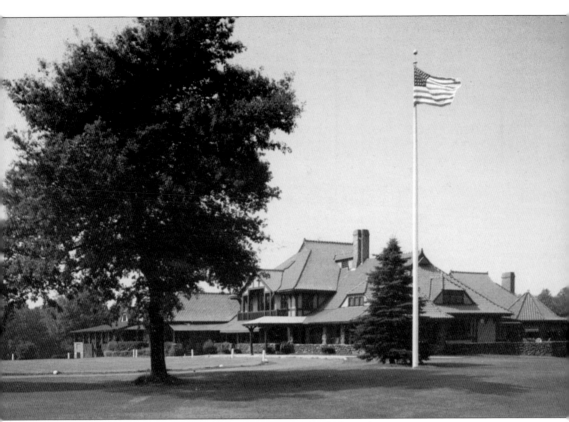

The New Haven Country Club is located on Hartford Turnpike.

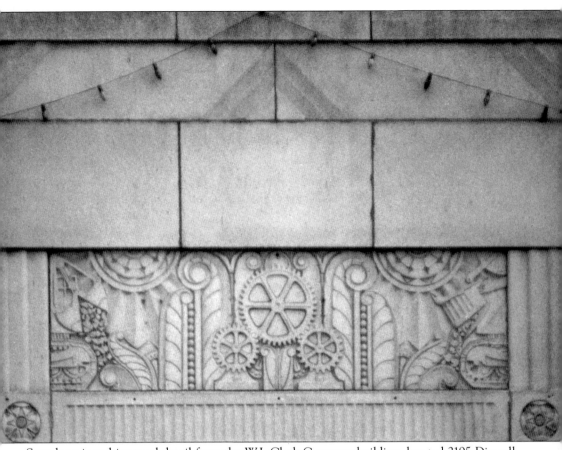

Seen here is architectural detail from the W.I. Clark Company building, located 2195 Dixwell Avenue, in 1941. The entablature is now mounted at the entrance to Government Center.

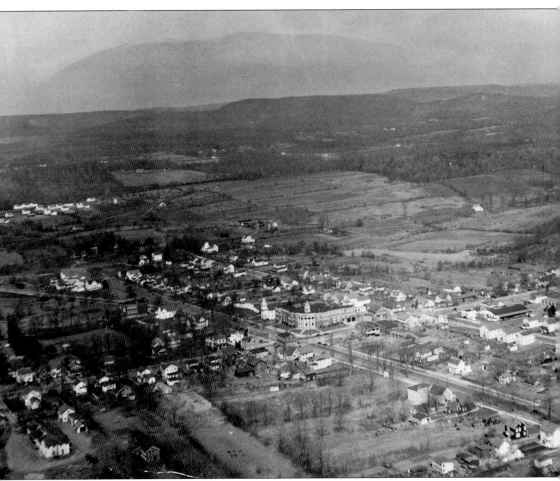

In this c. 1930s view of Centreville from the air, the gradual consolidation and spread of the new downtown can be seen. This photograph may well have been taken from a plane based at the nearby Hamden Airport.

Three

HAMDEN IN WORLD WAR II

This honor roll tribute to 1,800 Hamden men and women who served in the armed forces during World War II was dedicated in September 1945. It was located west of Grace Episcopal Church on the north side of Dixwell Avenue (before the church was moved across the street to its current location).

The High Standard Manufacturing Corporation, located at 1817 Dixwell Avenue, was a stone masonry structure with Gothic detailing. The firm originally made hardware but began producing gun parts when World War II broke out.

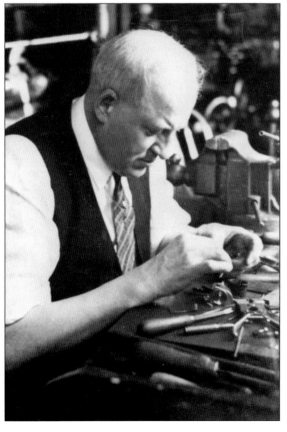

Carl Gustave Swebelius had worked with Marlin Firearms during World War I, and with that experience, he founded High Standard in 1927. Known as "Gus," he is shown here examining gun barrel parts.

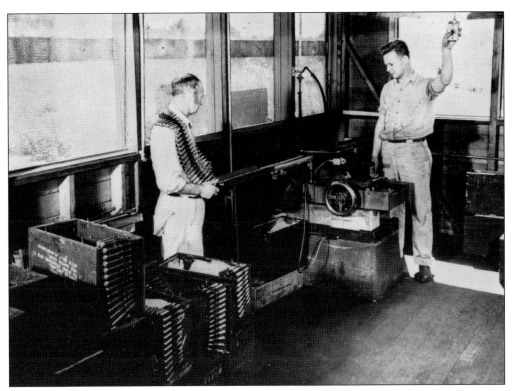

High Standard employees test the
bolt action of the machine guns
they manufactured.

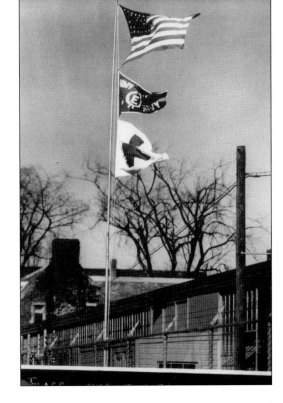

Flying in front of the factory was an
Army-Navy "E" Award flag, a production
achievement honor given by the US
government in 1942 to the High Standard
Company. By the end of the war, the
company had manufactured 340,000
machine guns.

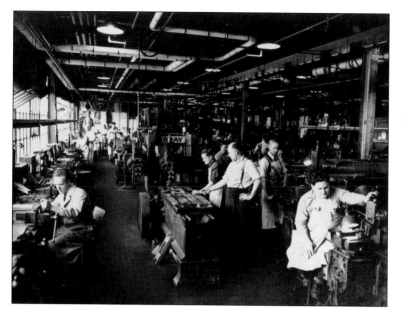

Machine workers in the High Standard Company are pictured. A high quality of skill was necessary for the precision guns that were produced.

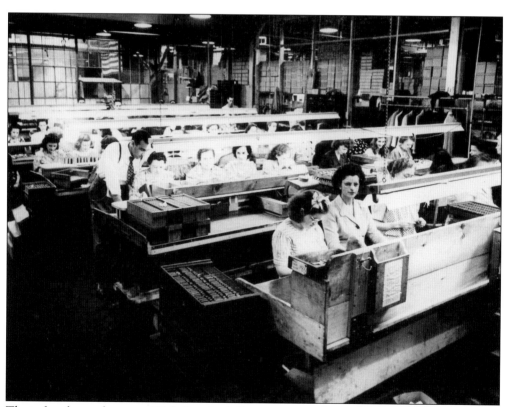

These female employees at High Standard Company provide an illustration of the vital role women played in manufacturing on the home front.

S.Sgt. Joseph Myjak is shown in Germany in 1945 as a member of General Patton's 106th Infantry, 3rd Army. He was awarded a Purple Heart, a Bronze Star, and the French Medal of Honor.

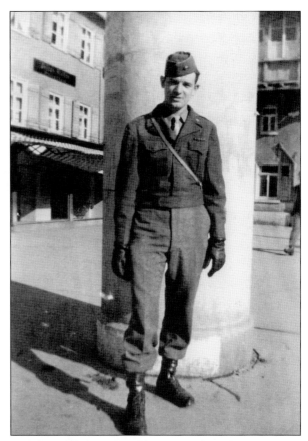

Myjak landed at Pointe Du Hoc near Omaha Beach at Normandy, France, on D-Day, June 6, 1944. He served in the 2nd Ranger Battalion, 1st Infantry Division Group, 1st US Army.

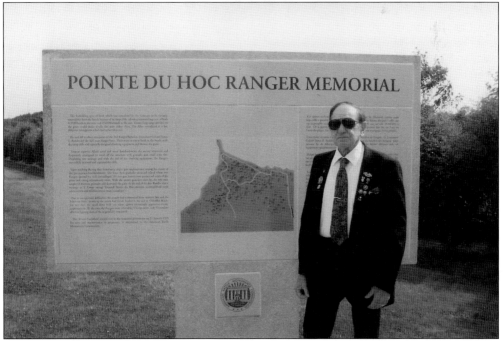

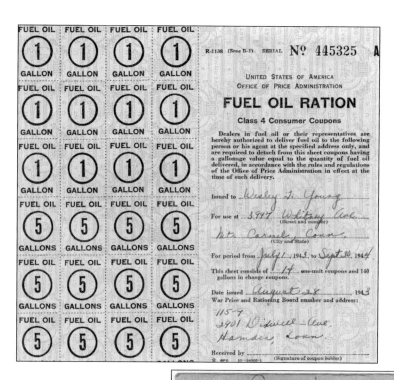

A vestige of wartime shortages: the Fuel Oil Ration book, 1943–1944, with attached stamps, of Wesley Young of Mount Carmel.

In this image are a picture of a war ration book (top), dated 1943, and mileage coupons (bottom) from 1945. The war ration book belonged to Mary Arnold of Mount Carmel.

JAMES EDWARD McCAULEY

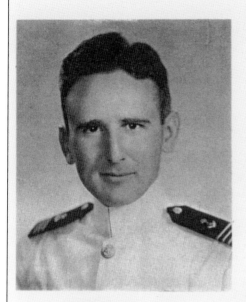

MIDSHIPMAN, USNA

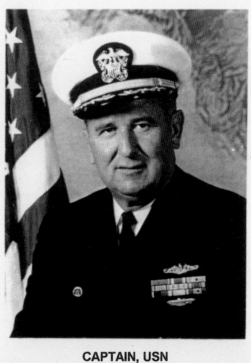

CAPTAIN, USN

Pictured here is James Edward MacCauley, who had a distinguished career in the US Navy from 1938 to 1973. He graduated from the US Naval Academy at Annapolis in 1944, eventually reaching the rank of captain. For his services during the Vietnam War, he was awarded the Legion of Merit and two gold stars. He retired in 1973 and passed away five years later.

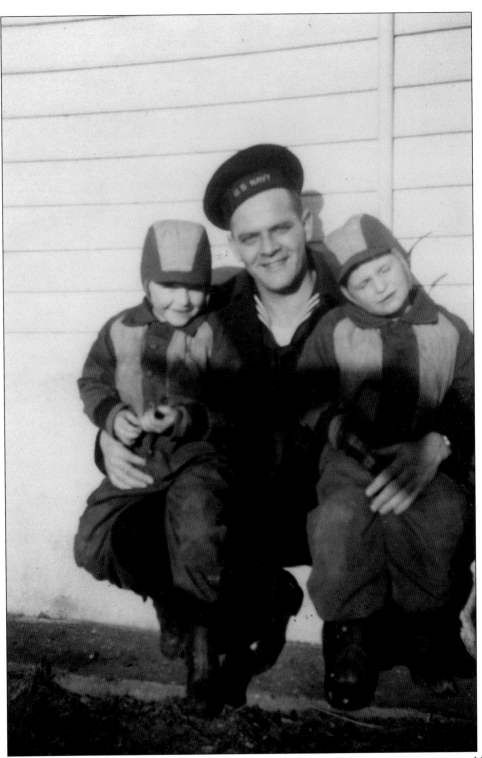

An unidentified Hamden seaman poses with two young boys in matching snowsuits, presumably his sons.

Four

THE MID-CENTURY

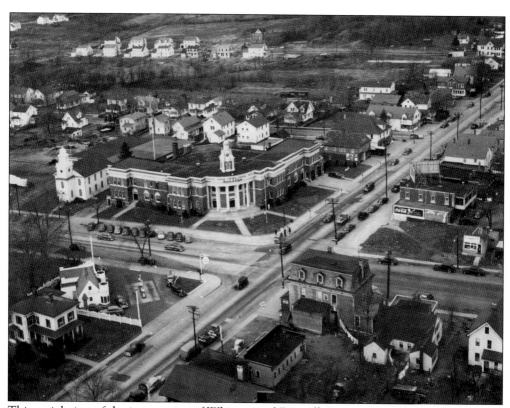

This aerial view of the intersection of Whitney and Dixwell Avenues was taken in 1949.

In 1946, Bob Peters built a roadside stand at Dixwell Avenue and Skiff Street to sell his farm's produce, fruits, and vegetables. In 1950, Peters Farm Market expanded into the nursery business.

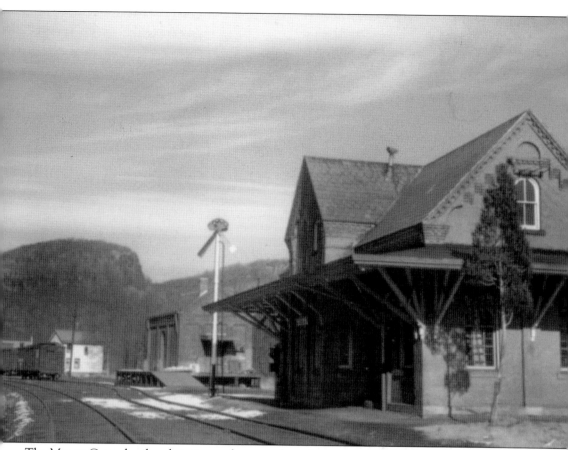

The Mount Carmel railroad station and rear yard are shown here in 1947. This was the second station built after the railroad tracks were moved westward away from the Cheshire Turnpike in 1881.

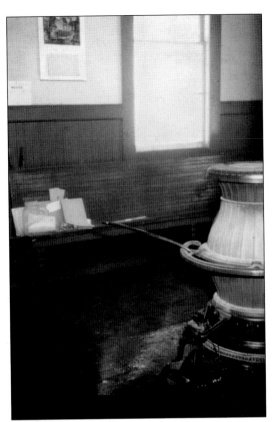

This view shows the interior of the Mount Carmel Train Station on December 31, 1947. (Photograph by Leone Rice Grelle.)

Steam engine No. 3019 is pictured on the Mount Carmel line on April 2, 1948. Trains ran on this line until 1980, when the track cut was converted to a pedestrian path for the Farmington Canal Greenway. (Photograph by Leone Rice Grelle.)

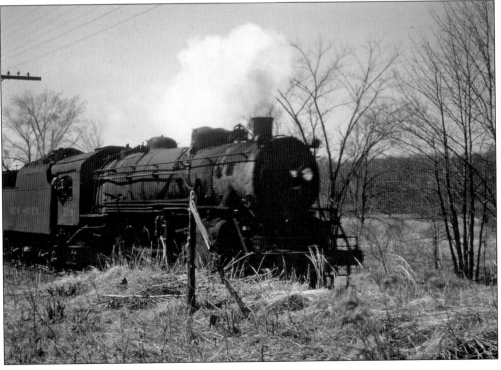

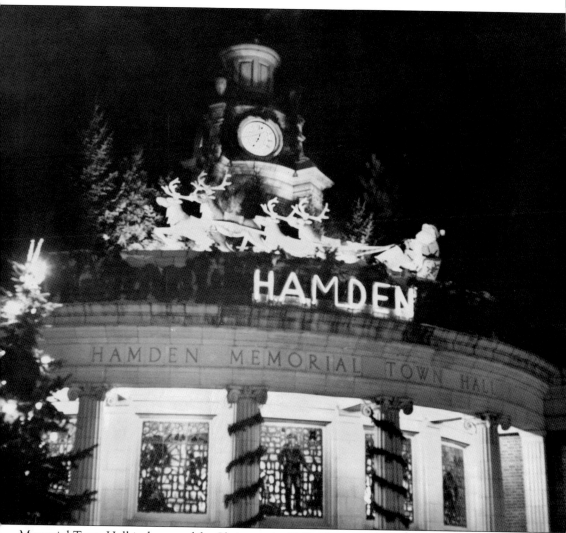

Memorial Town Hall is decorated for Christmas in 1947. (Photograph by David L. Dunn.)

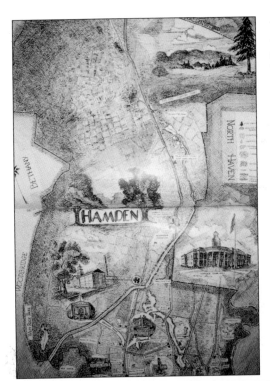

This map drawing by Raymond Gauvin was published by the Hamden Chamber of Commerce in 1948.

The Rotary Club of Hamden was chartered in 1937. Composed of highly regarded businessmen, its motto was "Service Above Self." Dedicated to high ethical standards in their business and personal lives, the all-male club members worked together toward the betterment of their community. "He profits most who serves best" was an oft-repeated theme.

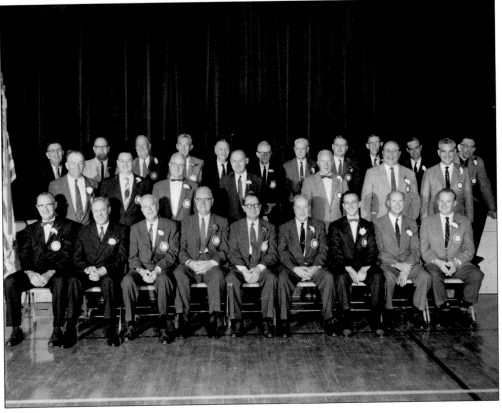

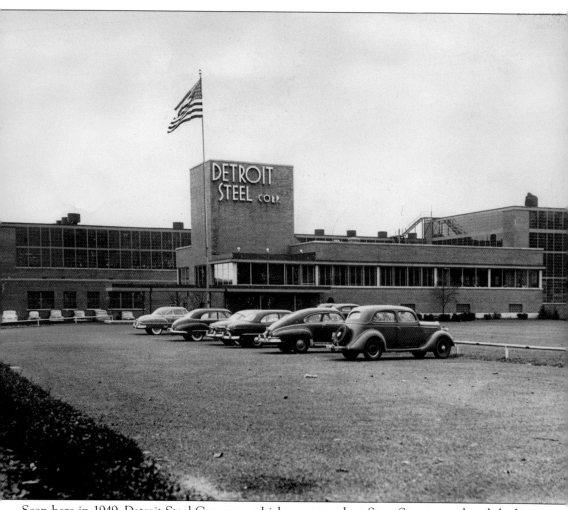

Seen here in 1949, Detroit Steel Company, which once stood on State Street, was demolished in the 1990s.

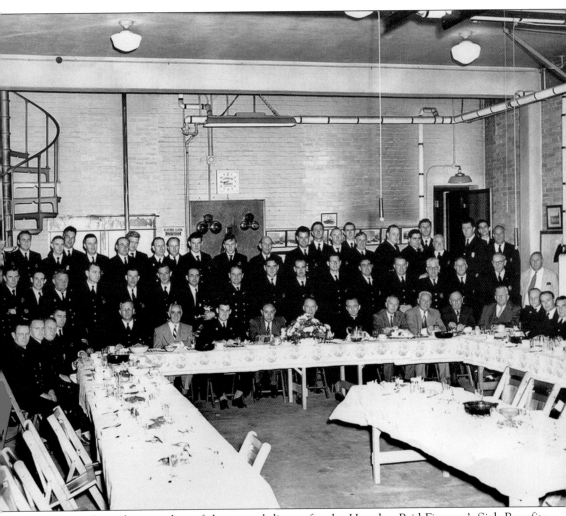

Pictured are the attendees of the annual dinner for the Hamden Paid Firemen's Sick Benefits Association at the Fire Headquarters on October 10, 1950.

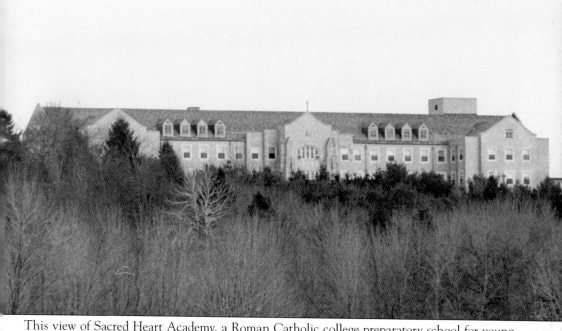

This view of Sacred Heart Academy, a Roman Catholic college preparatory school for young women founded by the Apostles of the Sacred Heart of Jesus, was taken from Dunbar Hill. Founded in New Haven in 1946 by Sr. M. Antonine Signorelli, the growing school moved to its current location along Benham Street in 1953. (Photograph by Leland Robinson.)

The modern Brock-Hall Dairy Company building, located on Whitney Avenue, was torn down in 1983. The company started operating in 1937, with plants in Hamden, Bridgeport, and Waterbury that produced milk, cream, and ice cream. The amber glass milk bottles in which the company dispensed its product are now collectors' items.

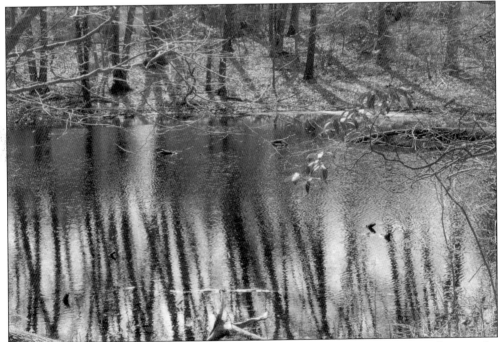

Johnson's Pond, now owned by the Hamden Land Conservation Trust, is off Thornton Street and is referenced in Donald Hall's poem *Kicking the Leaves*: "when we walked together in Hamden, / before the war, when Johnson's Pond had not / surrendered to houses." (Photograph by John Carolla.)

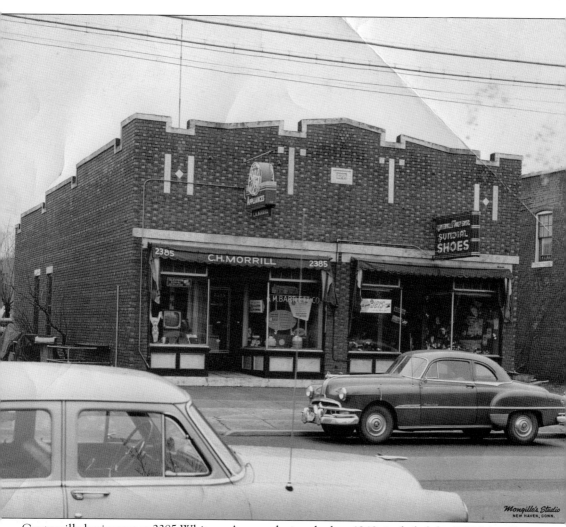

Centreville businesses at 2385 Whitney Avenue during the late 1940s included the C.H. Morrill Appliance Store and Centreville Boot Shop.

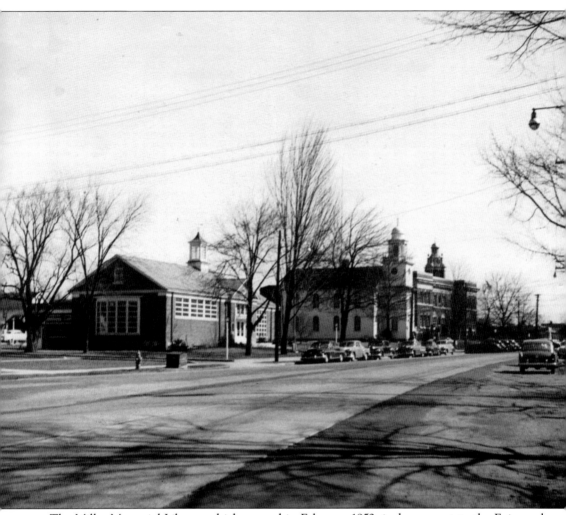

The Miller Memorial Library, which opened in February 1952, is shown next to the Episcopal church before it was moved to the other side of Dixwell Avenue in 1966. (Photograph by Margaret E. Beschel.)

Pfc. Marvin Cohen of the 25th Infantry Division was stationed at Pohakuloa, Hawaii, in 1956 and 1957.

Marvin Cohen is pictured at the Schofield Army Base barracks in Gen. Edwin Walker's helicopter.

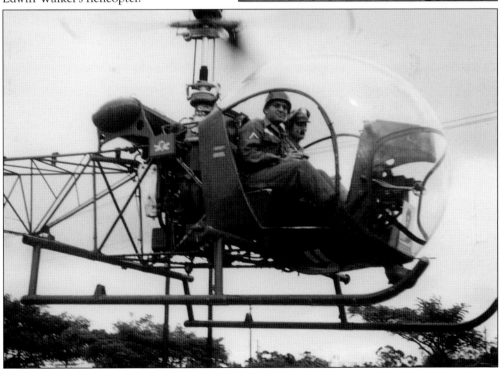

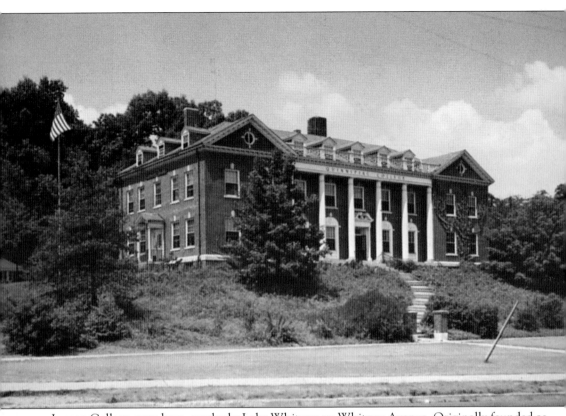

Larson College, seen here, overlooks Lake Whitney on Whitney Avenue. Originally founded as Connecticut College of Commerce in New Haven in 1929 and renamed Quinnipiac College in 1951, the school assumed control of Larson College, a private women's college, the next year.

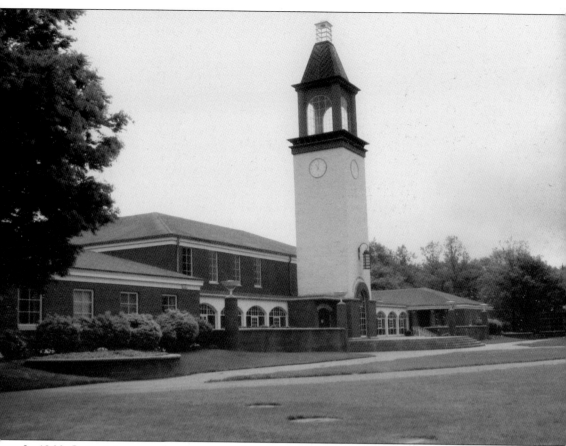

In 1966, Quinnipiac moved to its current location in Mount Carmel near Sleeping Giant State Park (SGSP). In 2000, the institution changed its name Quinnipiac University.

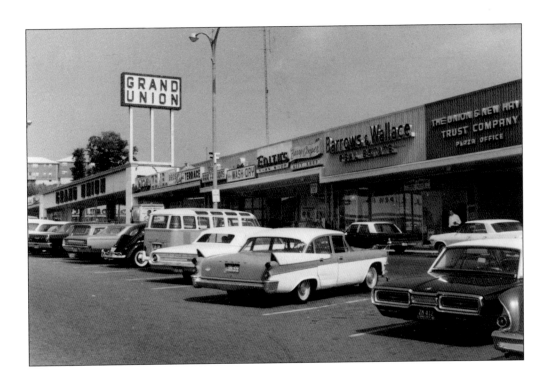

Once the site of an apple orchard on Dixwell Avenue, the Hamden Plaza was constructed in 1955. It was one of the first modern shopping malls in Connecticut, becoming a hallmark of suburban living.

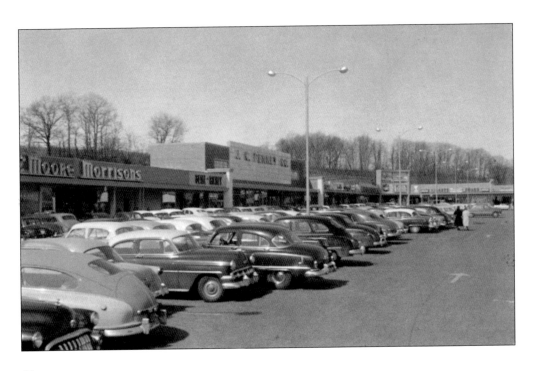

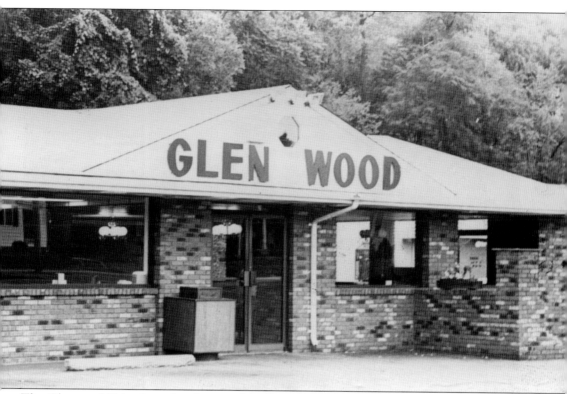

The Glenwood Drive-In, a family-owned and -operated business on Whitney Avenue, was established in 1955.

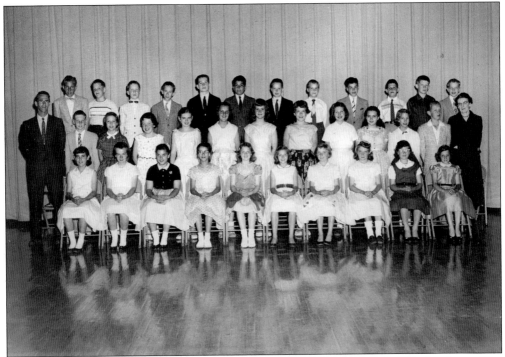

The Alice Peck School's sixth-grade class is pictured here during the 1956–1957 school year. The class teacher was John W. Stevin, and the school principal was Grace Donahue.

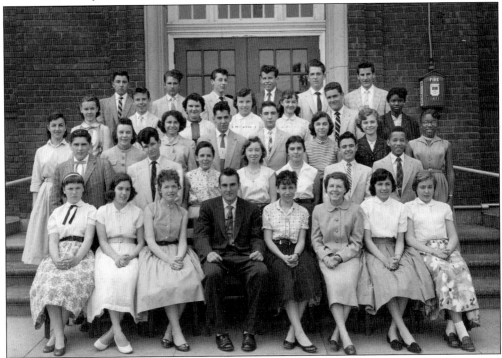

The postwar generation comes of age in pompadours and poodle dresses, as evidenced here by the Newhall School graduating class of 1956.

This image was captured during opening day of peewee baseball at Bassett Park in 1956. During this period, Hamden's recreational budget and facilities more than doubled in order to meet the growing population and the need for activities.

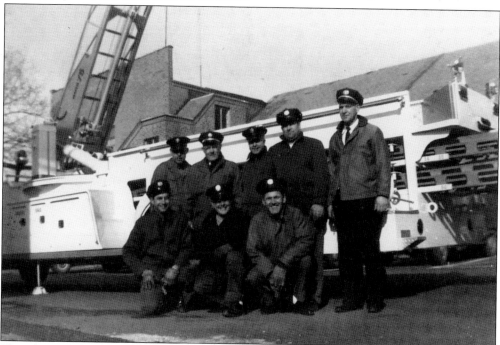

This photograph was taken in the side parking area of the Circular Avenue fire station (station No. 2) in December 1958, shortly after the delivery of a new aerial ladder truck. From left to right are (kneeling) Joe McDermott, Sid Trower, and Hugh McLean; (standing) Dick Stacey, battalion chief training officer Daniel Hume, Dave Herrmann, Mickey Cantarella, and Capt. James Strain. (Photograph by Joe McDermott.)

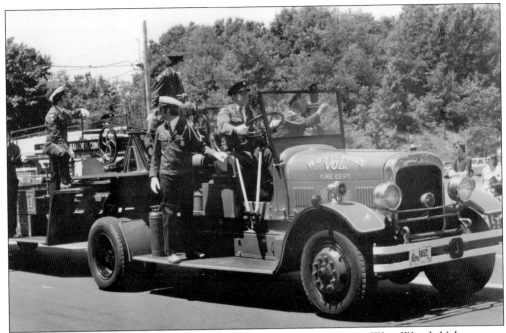

West Woods Volunteer Fire Association, Co. 9, is pictured here with its 1929 Seagrave tiller aerial ladder truck, which was used as a parade piece in many Memorial Day parades in the 1960s and 1970s.

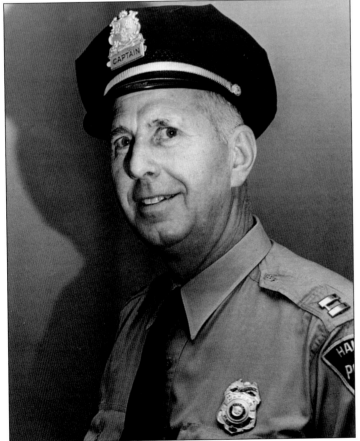

Pictured is Royce Malone, who was part of the Hamden police force from 1925 to 1963. He ended his service as a captain.

Five

THE 1960s

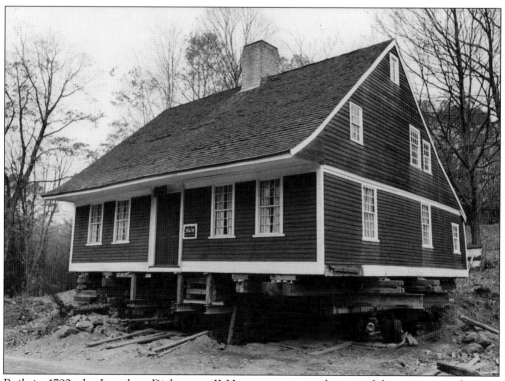

Built in 1792, the Jonathan Dickerman II House prepares to be moved from its original site in Sleeping Giant State Park to its new location on the south side of Mount Carmel Avenue in 1963. The house museum is owned and maintained for the public by the Hamden Historical Society, Inc.

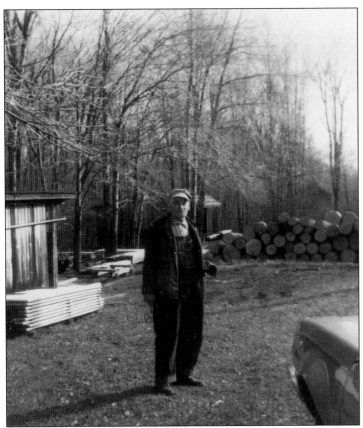

Art Doolittle is shown at his sawmill on West Todd Street on April 1, 1962. Originally, a sawmill had been established nearby by Waite Chatterton in 1747. He operated it until selling it to his cousin Horace Doolittle. Horace's nephew Oswin replaced the original up-and-down saw with a circular one in 1879 (shown below) and built a new structure to house it. A number of Doolittles lived in the West Woods area as farmers, woodcutters, and operators of the sawmill. This sawmill has continued to operate into the 21st century.

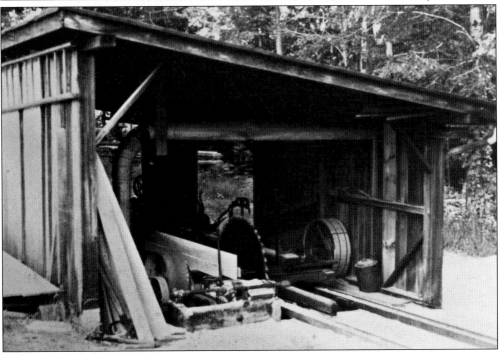

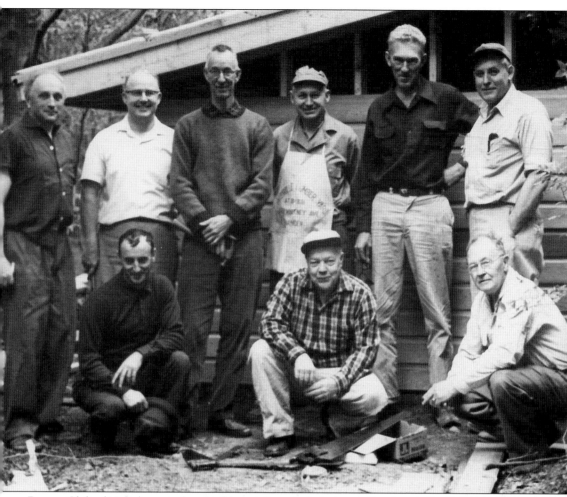

Rotary Club of Hamden members build an Adirondack shelter at Brooksvale Park in 1961. From left to right are (kneeling) Al Occone, Sam Caldwell, and Kurt Conley; (standing) Hans Hecker, Gus Dougherty, Maskell Hunt, Doc Spicer, Dave Beers, and Ed Beattie. The Rotary Club of Hamden was founded in the 1930s as a community service organization with the motto "Service above Self."

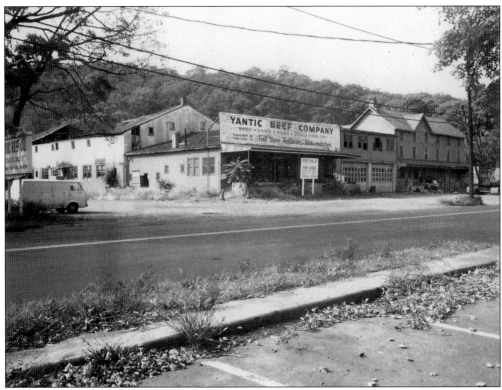

In the 1960s, a "For Sale" sign sits on the site of the Yantic Beef Co. and its neighbor, the Hamden Grain Co., at 3308 Whitney Avenue. With the Mount Carmel railroad station and freight building behind them, they illustrate the passing of a more rural Hamden.

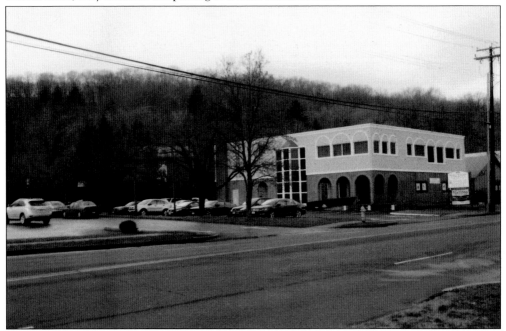

Pictured is the same site in 2012, just north of the Sherman Avenue intersection.

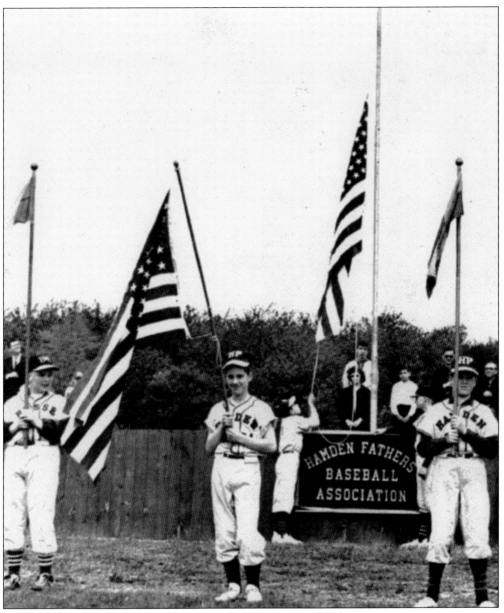

In this 1963 image, Little League opening day ceremonies take place.

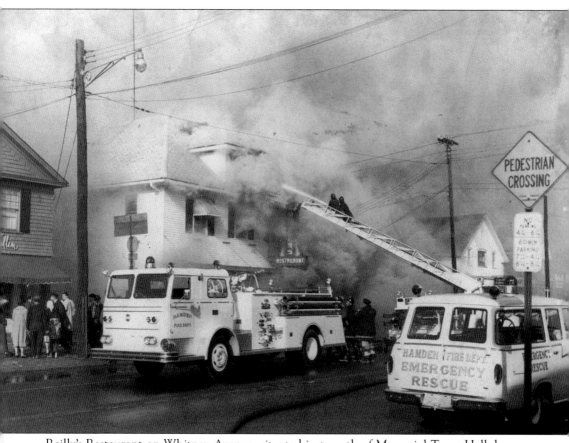

Reilly's Restaurant on Whitney Avenue, situated just north of Memorial Town Hall, burns on Christmas Day in 1964.

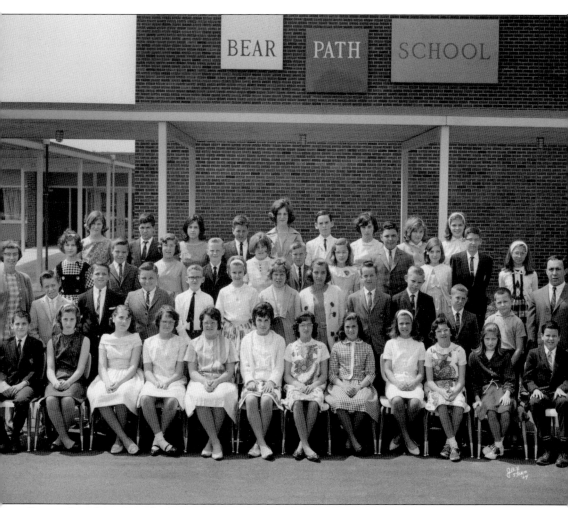

Pictured is a Mrs. Dowd's class at Bear Path School in 1964.

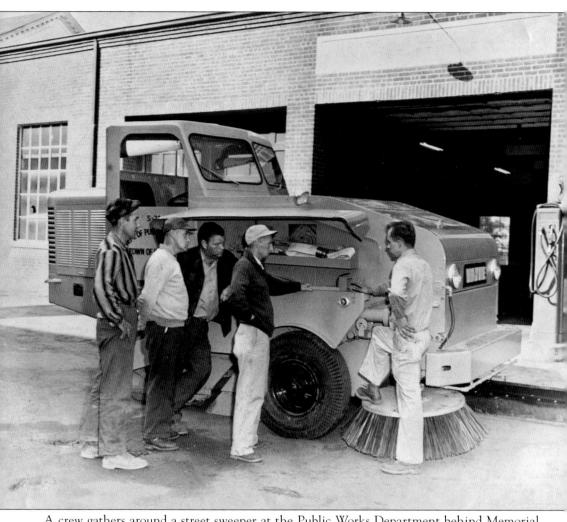

A crew gathers around a street sweeper at the Public Works Department behind Memorial Town Hall.

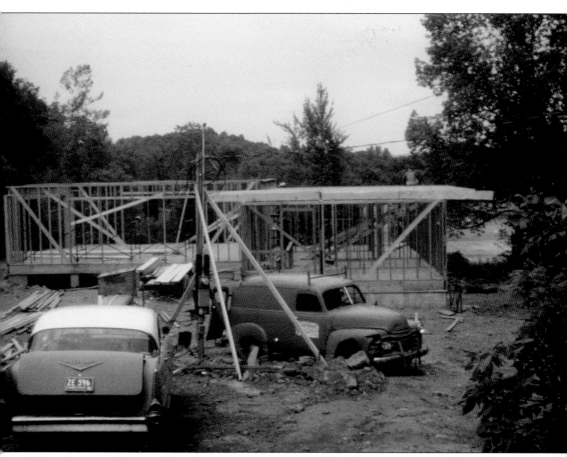

This photograph was taken during construction of the Veterans Memorial Building at Brooksvale Park in 1965. It is dedicated to those who served in the armed forces. (Courtesy of the Grandy family.)

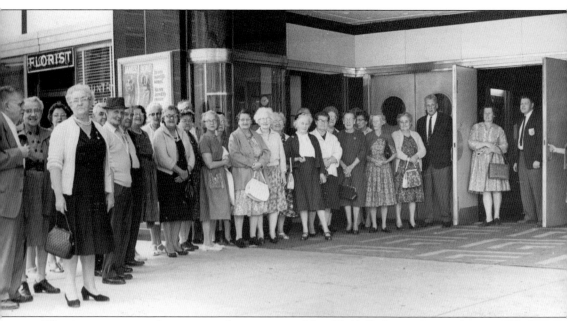

These seniors are ready to enjoy a free movie on May 27, 1965, during Senior Citizens' Week. (Courtesy of Al and Gert Baines.)

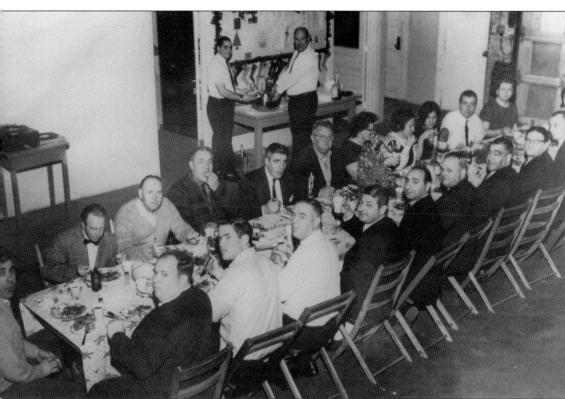

Hamden Parks and Recreation Department holds a Christmas lunch around 1965. Among the attendees are Mayor DeNicola Sr., John Gambardella, Frank Warner, Everett Doherty, Gert Robinson, Jay Burwell, Jerime Alberino, Virginia Ponescia, Fred D'Anniello, Rich Cumpstone, Joe Burno, Joe Frapasso, Art Talmadge, and Jim Grandy.

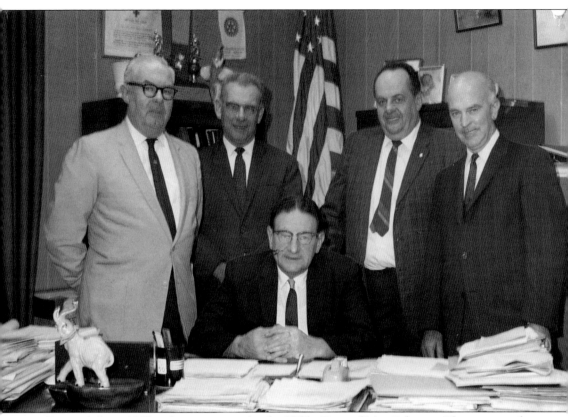

Pictured about 1965 is the committee for the "Olde Gang of Mine" dinner. The men are, from left to right, (seated) Mayor John DeNicola Sr.; (standing) Ed "Stuffy" Sullivan, Vic McLaughlin, Phil Egan, and Bob Murphy.

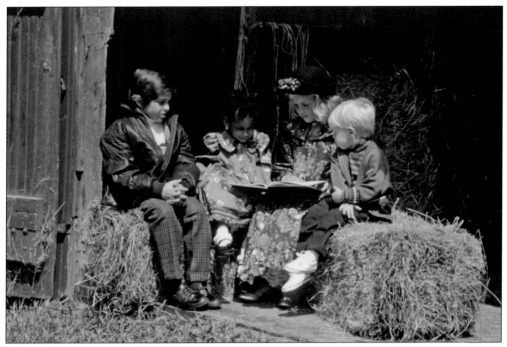

Children enjoy an activity on hay bales outside the barn at Brooksvale Park. (Courtesy of the Grandy family.)

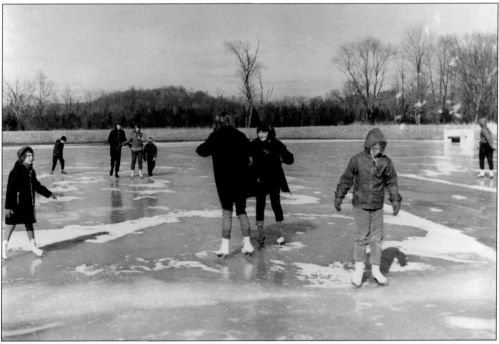

Ice-skating was a popular winter activity at Brooksvale Park, a 400-acre nature park and wildlife sanctuary with hiking trails, a domestic animal zoo, playing fields, and picnic areas. (Photograph by I.A. Sneiderman.)

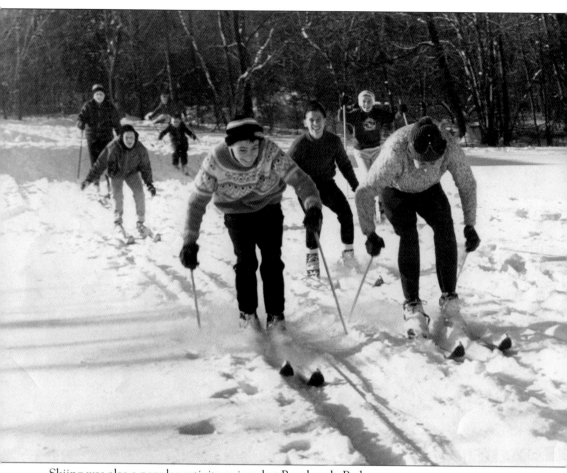

Skiing was also a popular activity enjoyed at Brooksvale Park.

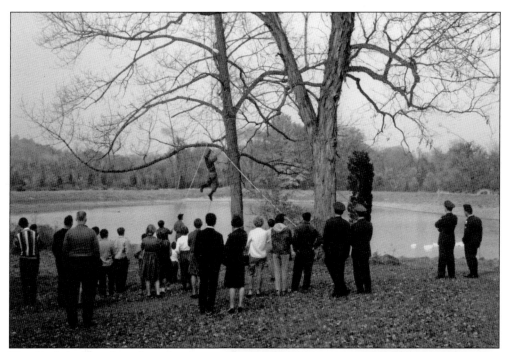

The Civil Air Patrol conducted
training exercises at Brooksvale Park.

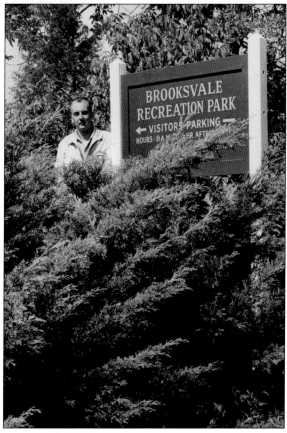

Brooksvale park supervisor Jim
Grandy stands by the park's new sign
in 1967.

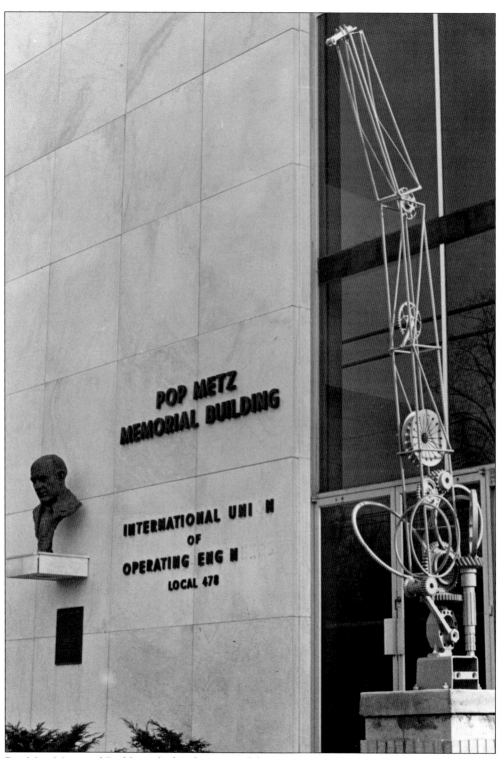

Pop Metz Memorial Building, the headquarters of the International Union of Operating Engineers, Local 478, is located on Dixwell Avenue.

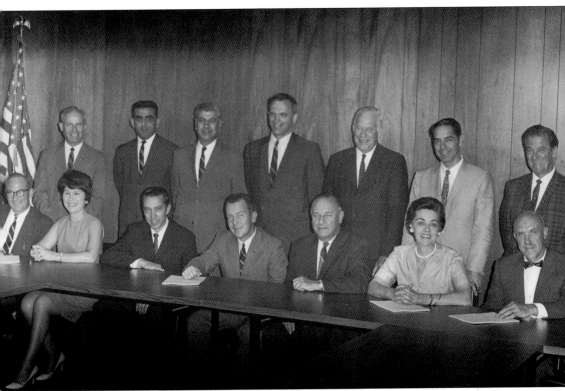

In 1966, Hamden changed its form of government from selectmen to a mayor and council. The first Hamden Legislative Council, serving during 1966–1967, included, from left to right (seated) Paul Kerrigan, Frances Mulqueen, Vincent Richo, Pres. Herbert Emanuelson, clerk Hans Wiedenmann, Hilda Sanford, and Bingham Humphrey; (standing) Lawrence Albertini, John Carusone, Ernest DeFrank, Peter Dorsey, Garrett Lambert, Albert Sheppard, and Elton Wetmore.

The Hamden Arts Commission presented its Saturday afternoon family series in Thornton Wilder Auditorium in 1966. (Courtesy of the Hamden Arts Commission.)

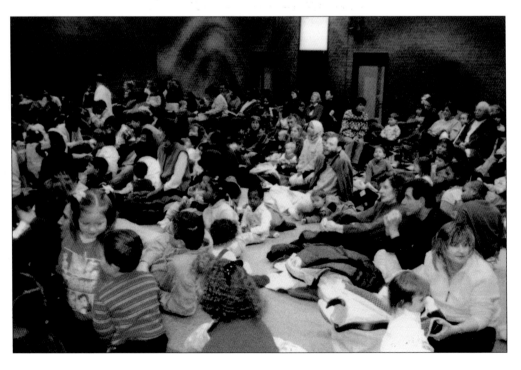

Six

THE 1970s

Thornton Wilder, born in 1897, is America's only writer to have won a Pulitzer Prize for both drama (twice) and fiction. He lived in Whitneyville from 1929 until his death. His play *The Matchmaker* ran for 486 performances on Broadway in the mid-1950s; it was later adapted into the musical *Hello, Dolly!* Wilder is seen here in the role of Mr. Antrobus, the narrator in his play *The Skin of Our Teeth*, in 1942. He died in 1975.

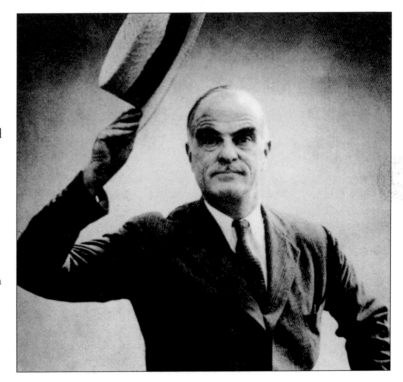

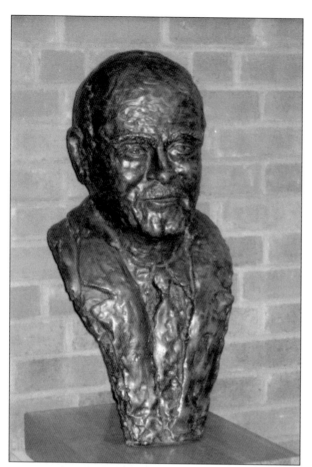

This bust of Thornton Wilder by sculptor Anthony Bonadies is in the Miller Memorial Library. The library also contains Wilder's study, preserved from his home on Deepwood Drive.

This photograph shows one of Hamden's popular restaurants, located at 2285 Whitney Avenue. The Carriage Drive boasted that it was "designed for gracious dining" and featured air-conditioning. Built in 1845, the structure provided housing for some of the workers at the Candee Rubber Shoe Factory, which was part of the largest industry in Hamden at the time.

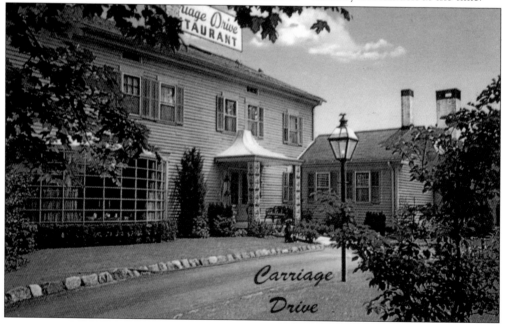

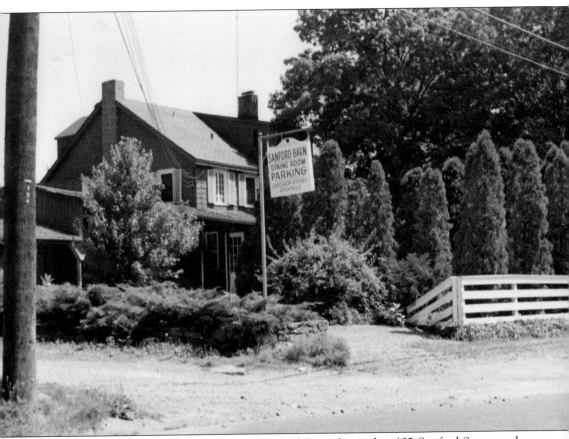

Featured is a picture of another restaurant, Sanford Barn, located at 135 Sanford Street and adjacent to Turner's Pond. The pond's waterfall provided power for the mill, which was operated by the family in the late 1800s. The restaurant was demolished in 1972.

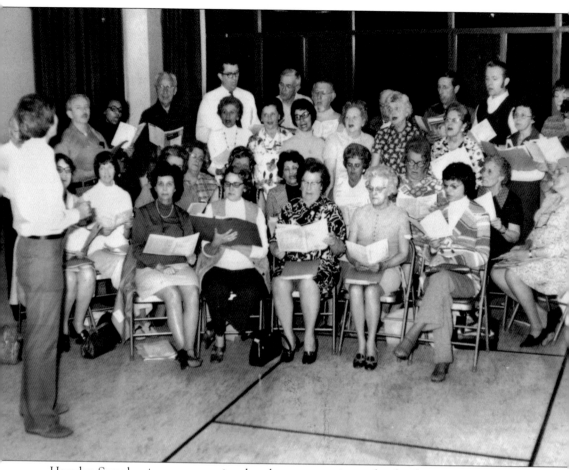

Hamden Symphonics, a community choral group, practice under the direction of Robert Reed. Founded in 1972, the organization later changed its name to Hamden Festival Chorus.

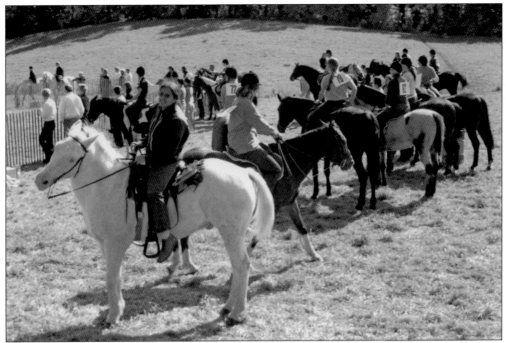

On the north hay field at Brooksvale Park, the 4-H Club conducts a horse show in the 1970s.

Brooksvale park ranger Jim Grandy arranged for Hamden seniors to enjoy a picnic at the park.

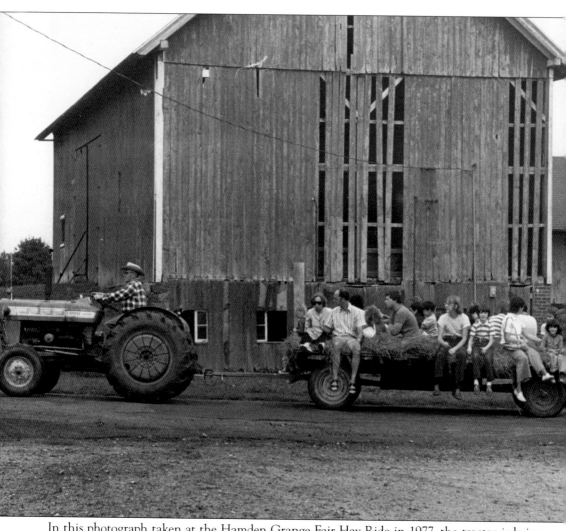

In this photograph taken at the Hamden Grange Fair Hay Ride in 1977, the tractor is being driven by Ed Hooghkirk.

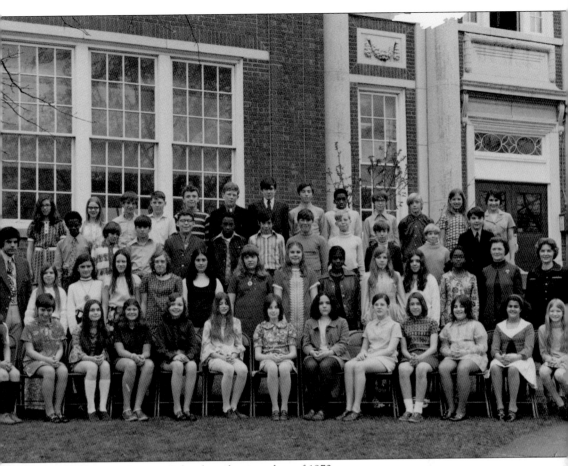

This is the Putnam Avenue School graduating class of 1972.

Pictured is Richard Jacobs, a physics teacher at Hamden High School, who lived near Clark's Pond.

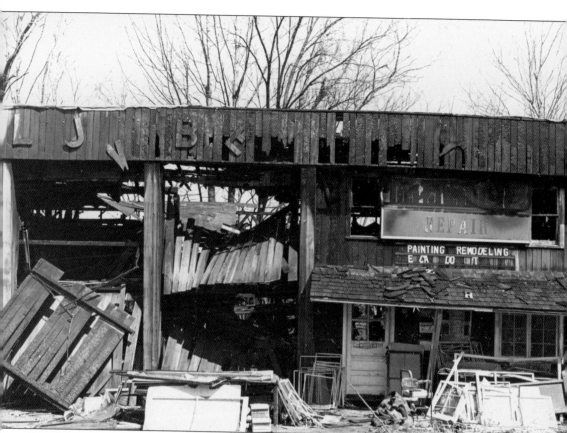

Seen here is Corey Lumber Company, located on Dixwell Avenue, after it was destroyed by fire in April 1979. (Photograph by Leland Robinson.)

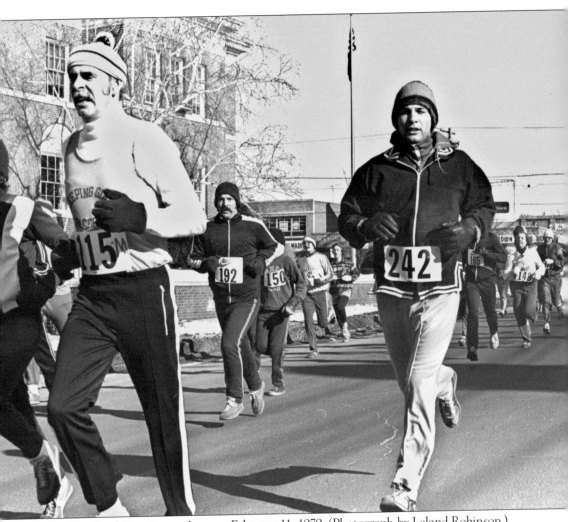

An Elks Road Race is seen here on February 11, 1979. (Photograph by Leland Robinson.)

Seven

THE 1980s

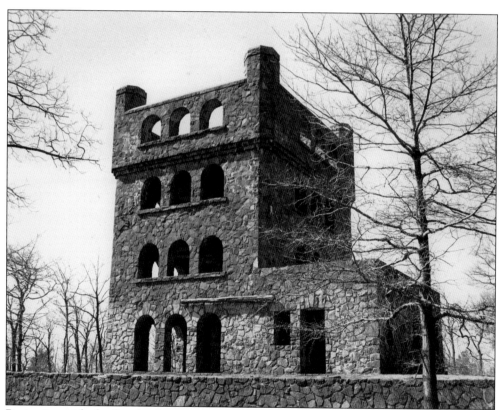

Beginning with the first land acquisition in 1924, Sleeping Giant State Park has become the symbol of Hamden, a place of legend and lore, and a statewide attraction for hiking. Shown is the north side of the Giant in the morning mist with the 50-year rededication of the tower, a Works Progress Administration (WPA) project, in October 1989. (Photograph by Burt Benham.)

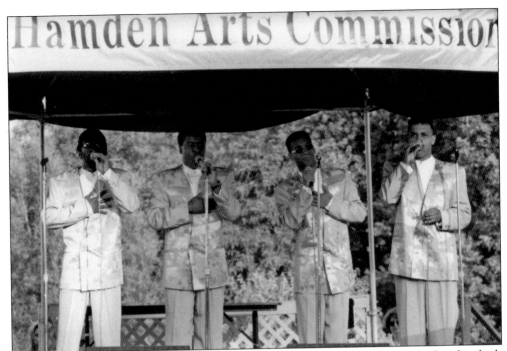

The 1980s welcomed the summer concert series to Town Center Park at Meadowbrook, which was presented by the Hamden Arts Commission. Well-known local a cappella group Soul Tempo performed one July. (Courtesy of the Hamden Arts Commission.)

The summer concert series grew over the years and featured nationally known groups, such as Three Dog Night. (Courtesy of the Hamden Arts Commission.)

Produce grown by the last of Hamden's dwindling number of farmers is on display for the town's Thanksgiving festival in 1983. (Photograph by Jackey Gold.)

Joshua Carey is pictured here at the Thanksgiving festival in 1983. (Photograph by Jackey Gold.)

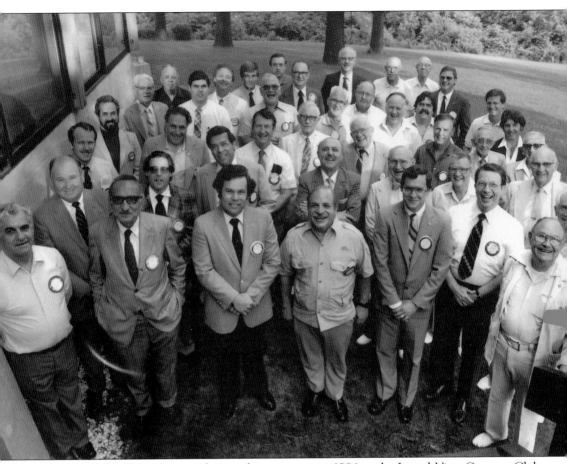

Rotary Club of Hamden members and guests pose in 1984 at the Laurel View Country Club. (Photograph by R. Paul Andersen.)

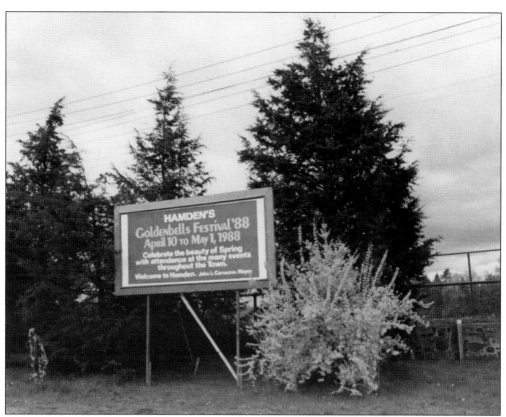

Hamden's Goldenbells Festival, founded by Chris Rendeiro, has been celebrated each spring beginning in 1971. It brings civic and community organizations, businesses, and schools together in celebrating Hamden's values at the time of seasonal renewal. The balloon liftoff at Eli Whitney Dam signaled the beginning of the festival in 1988.

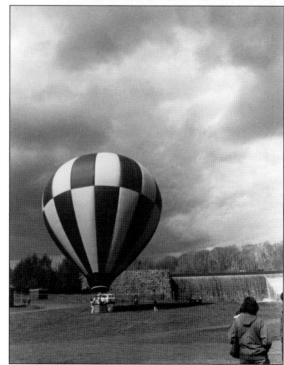

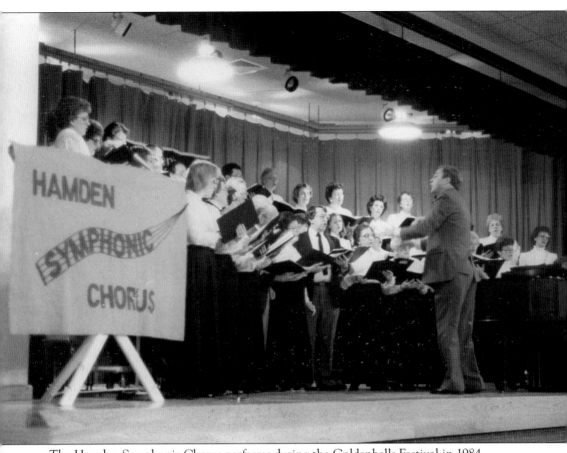

The Hamden Symphonic Chorus performs during the Goldenbells Festival in 1984.

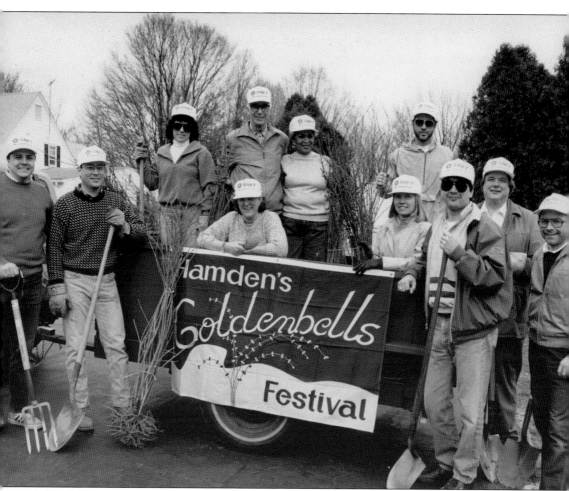

Goldenbells Festival volunteers get ready to plant forsythias at locations in Hamden in 1989.

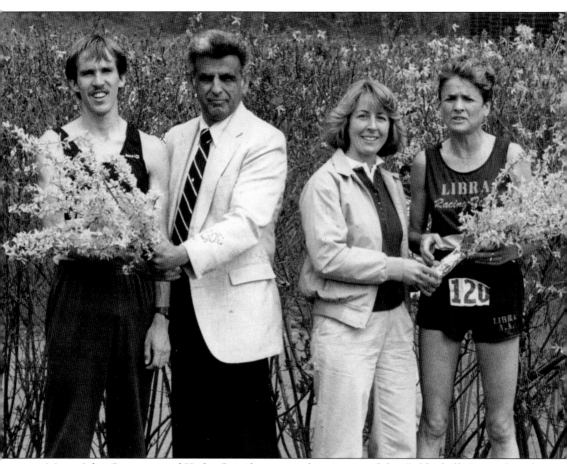

Mayor John Carusone and Kathy Gentile present the winners of the Goldenbells Festival road race with boughs of forsythia, the flower of Goldenbells. (Photograph by R. Paul Andersen.)

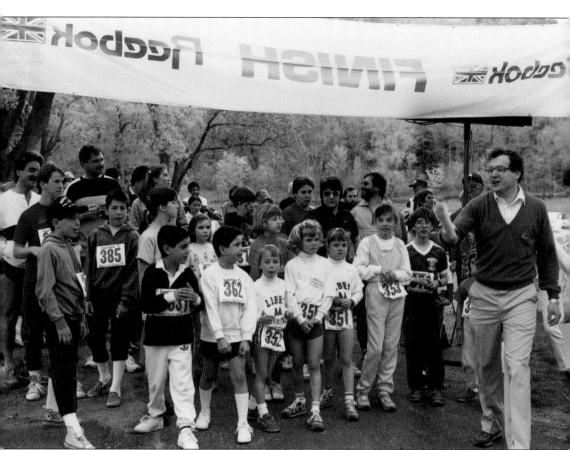

Tom Hylinski signals the start of the Rotary Club's kids' run in 1986. The 10K, 1-mile, and fun runs began at the Hamden YMCA. (Photograph by R. Paul Andersen.)

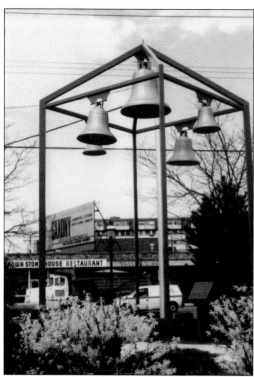

The campanile, or bell tower, was donated to the Town of Hamden by the children of Philip Paolella to honor Ciro Paolella, the founder and president of the Plasticrete Corporation, a well-known company for producing concrete products. The campanile and electronic carillon were given to memorialize the contributions of Hamden residents of Italian birth or descent. The gift was presented during the 1986 bicentennial celebration of Hamden's incorporation. (Courtesy of the Hamden Chamber of Commerce.)

The Hamden High School soccer team poses with Chris Rendeiro (center) and Hamden's longtime soccer coach Val Morretti (left) in 1989.

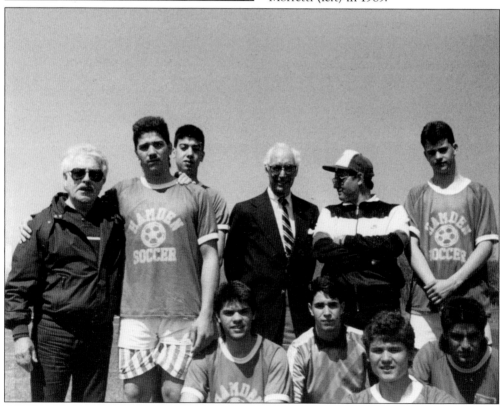

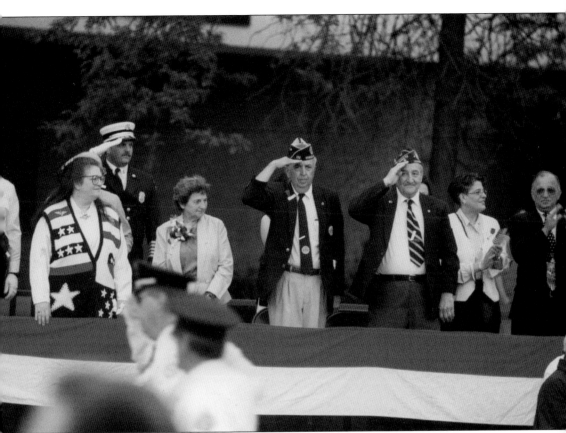

Dignitaries view the 1989 Memorial Day parade. From left to right are town clerk Vera Morrison, Fire Chief Tim Sullivan, Mayor Barbara DiNicola, unidentified veteran, council president Pat Corso, and council members Henry Candido and Leslie DeNardis.

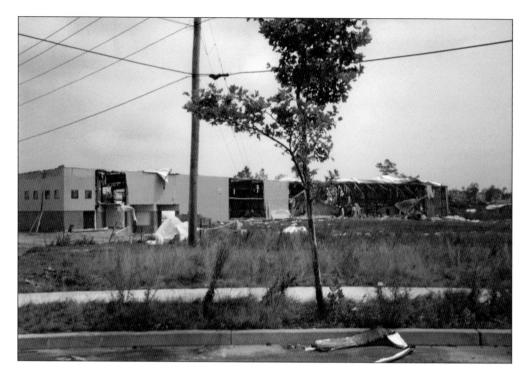

A tornado struck Hamden on July 10, 1989. In its path, it left 250 residents homeless and damaged 500 structures. These photographs were taken a few days later by Ret. Lt. Charles Atzbach. Above is the Industrial Park in Highwood, and below is Putnam Avenue looking east.

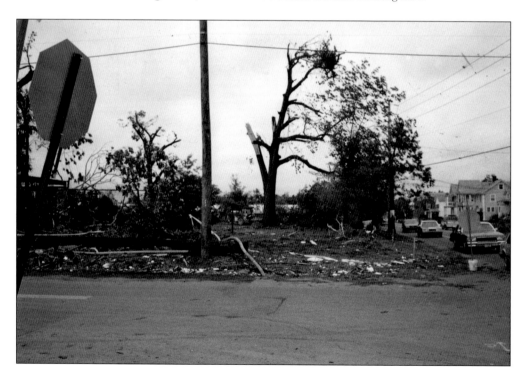

Eight

THE CENTURY'S END

The sky is aglow at Hamden's
Fourth of July fireworks
celebration, which has been
sponsored through the
fundraising efforts of Hamden's
Volunteer Firefighters since
1993. (Courtesy of the Hamden
Arts Commission.)

This holiday luncheon was sponsored by the Hamden Elderly Services Department.

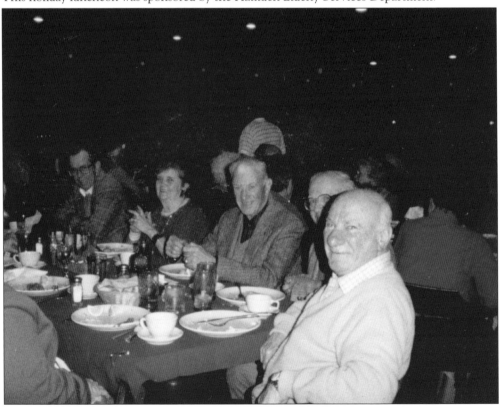

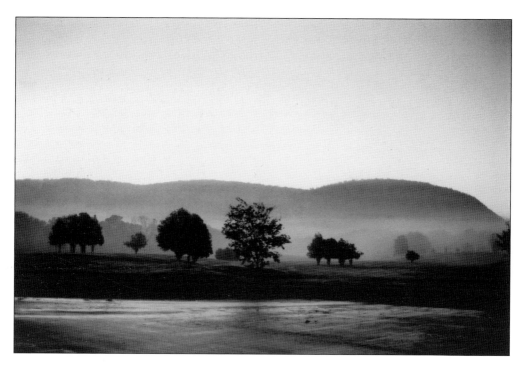

The Sleeping Giant Park Association (SGPA) was formed in March 1924 with the mission "to secure, acquire, preserve, and maintain land . . . in the vicinity of Mt. Carmel."

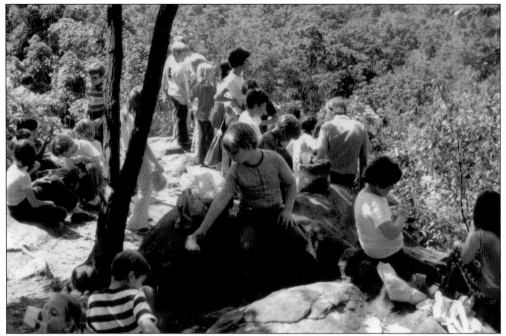

Summer campers enjoy a trip to the top of Sleeping Giant State Park. (Courtesy of the Grandy family.)

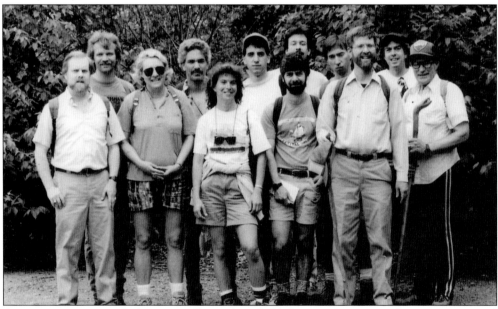

Organizing nature trails, history walks, and guided hikes, performing trail maintenance and conversion projects on over 30 miles of trails, and producing maps of the Giant and news through print and electronic media, the SGPA is a special guardian of Hamden's most visual natural asset. Members of the Trail Crew shown in 1990 include, from left to right, (first row) Jim Stevens, Johanna Becker, Christine Hezzey, Mike Ferrucci, and Tom Vocelli; (second row) Dave Carlson, John Menta, John Hogan, Armand Morgan, Burt Benham, Mike Benson, and Skip Gemmell. (Photograph by Bob Hoodes.)

In 1989, the state undertook a renovation project to commemorate the 50th anniversary of the completion of the Sleeping Giant State Park tower. This large fieldstone observation structure designed in the Normal style was constructed by the WPA under the supervision of Harry Webb. It is located on the third ridge of the Giant, situated at the park's highest point—739 feet—and affords a 360-degree view of the surrounding area. (Photograph by Ross Lanius.)

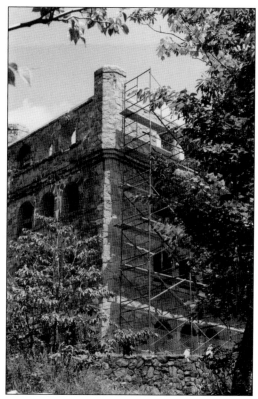

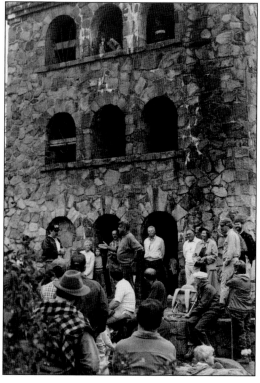

Mayor John Carusone addresses a group at the rededication of the tower, marking the 50th anniversary of its completion.

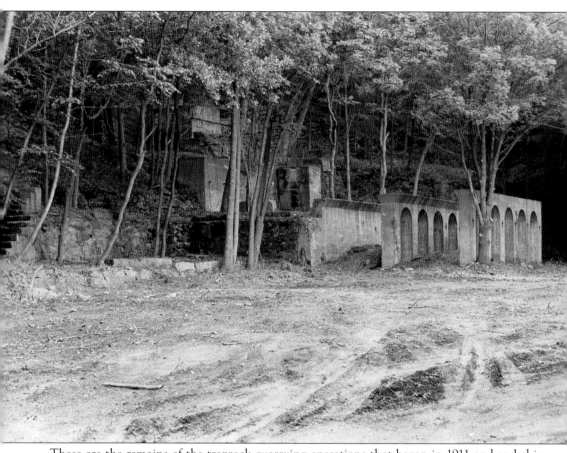

These are the remains of the traprock quarrying operations that began in 1911 and ended in 1934. Had these operations continued, the Giant would have been headless.

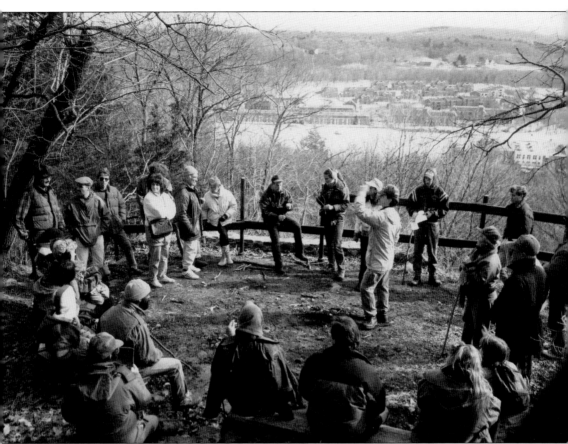

Each year, the Sleeping Giant Park Association offers a series of organized hikes to familiarize interested individuals with the natural and social history of the Giant. Here, in 1994, a group attends to Chris Fagan, as he instructs in winter tree identification. In the distance is Quinnipiac University. (Photograph by Irwin Beitch.)

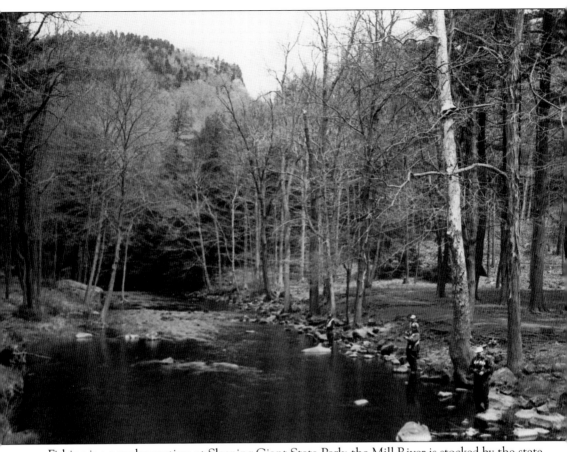

Fishing is a popular pastime at Sleeping Giant State Park; the Mill River is stocked by the state each year with trout, affording anglers an opportunity to catch and release. (Photograph by Irwin Beitch.)

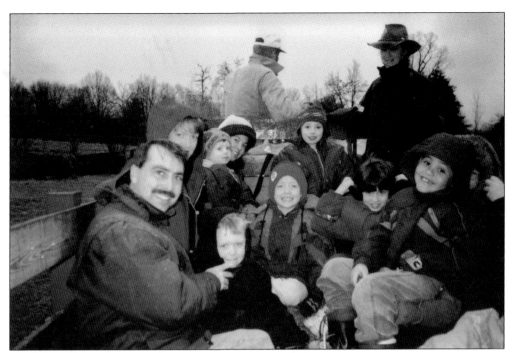

The Hamden Arts Commission sponsored the Hamden Silverbells Festival with a wagon ride in old Meadowbrook Park. (Courtesy of the Hamden Arts Commission.)

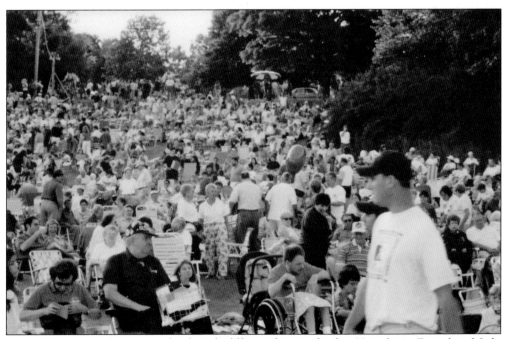

Town Center Park at Meadowbrook fills with people for Hamden's Fourth of July fireworks celebration.

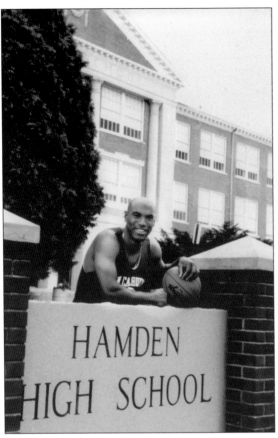

Visiting his alma mater in 1992, Scott Burrell was poised to be drafted into the NBA. After excelling at Hamden High School in basketball, baseball, and football, he was a starting guard on the University of Connecticut varsity basketball team. He was a first-round draft pick of two major sports teams in the NBA and MLB. Scott won an NBA championship ring with the Chicago Bulls in 1998. (Courtesy of the Hamden Chamber of Commerce.)

This picture was taken during a ground-breaking ceremony for the Farmington Canal Greenway at Todd Street in June 1994. From left to right are Mattie Mims, Vera Morrison, David Schaefer, Carol Noble, Kristin Hawkins, Margaret DeVane, Nancy Beals, Mayor Lillian Clayman, state senator Joe Crisco, and Pat Corso. Hamden converted the canal and railroad path into a 9.5-mile-long paved greenway trail from the Cheshire border to New Haven. (Photograph by Steve Buckingham.)

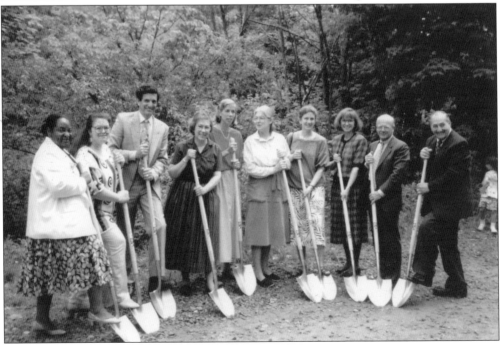

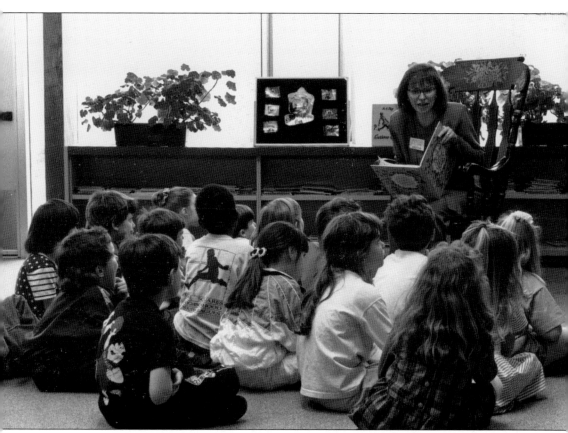

Mayor Lillian Clayman reads to students at Alice Peck School in April 1994.

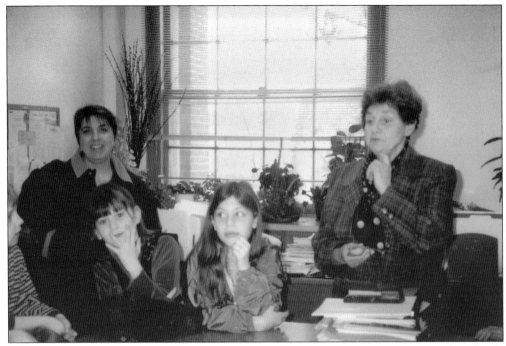

Mayor Barbara DeNicola (right), who served from 1997 to 1999, hosts West Woods School's second-grade class on a visit to Hamden's Memorial Town Hall. (Courtesy of Vera Morrison.)

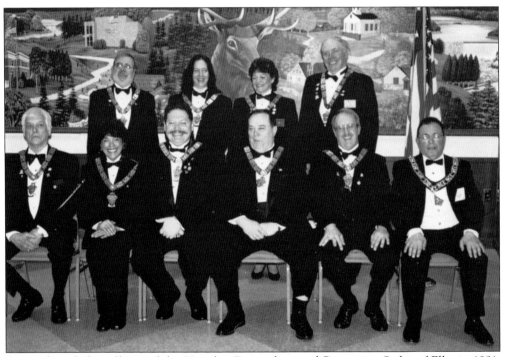

Pictured are lodge officers of the Hamden Benevolent and Protective Order of Elks in 1991. (Courtesy of Carl Rennie.)

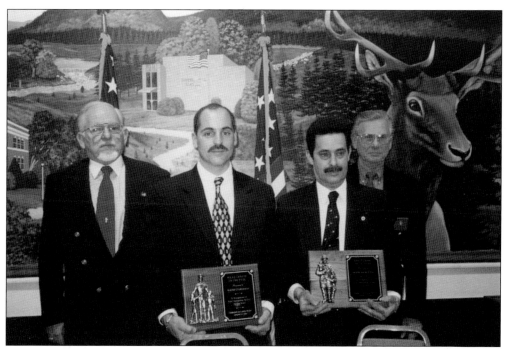

The Hamden Elks organization honors police and firefighters for the year 2000. Pictured from left to right are Robert T. Curran; Dave Ciarlelli, Hamden Police Department; Mark Barletta, Hamden Fire Department; and Carl Rennie, exalted ruler. The mural in the background was painted by Jeanne Trap in 1991. (Courtesy of Carl Rennie.)

The Hamden Chamber of Commerce Choice Award Recipients in 2000 were, from left to right, Larry DeNardis, PhD; Al Gorman; John Nutcher; Ed Della Valle; Elisabeth Joy Palquist; Mary Marrandino; Richard Veneris, and Arthur Veneris. The award originated in 1966 to honor individuals, businesses, organizations, and students in the community. (Courtesy of the Hamden Chamber of Commerce.)

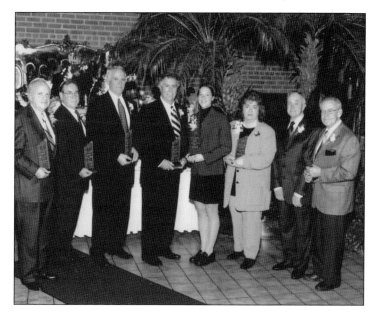

Fishing is taught at the Brooksvale Park camps each summer.

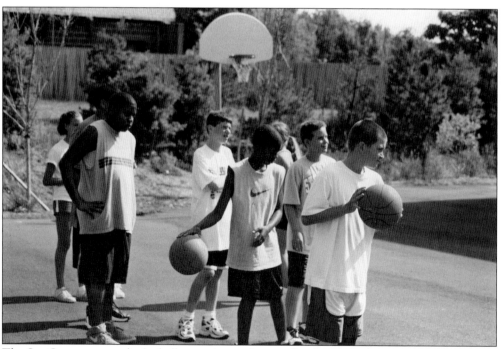

The Stu Grove summer basketball camp is seen here at Brooksvale Park around 2001.

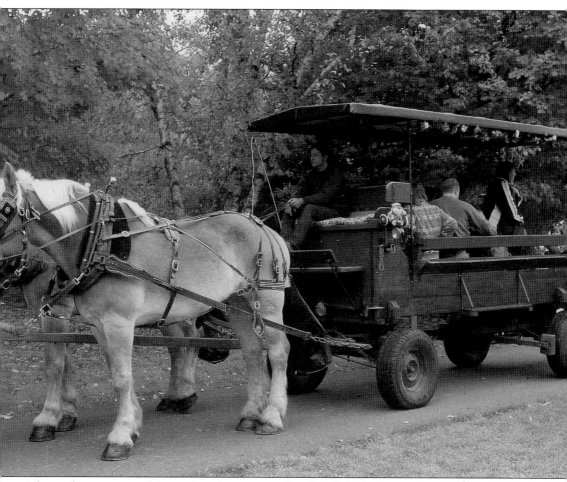

A horse-drawn wagon is shown during autumn at Brooksvale Park.

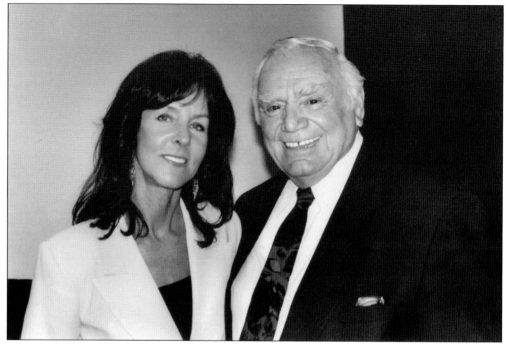

Ernest Borgnine, a famous American film and television actor, was born in Hamden on January 24, 1917. The Oscar winner for *Marty* and a popular star of television's *McHale's Navy* is pictured on a visit to Hamden with Mimsie Coleman, Hamden's director of arts and culture. (Courtesy of the Hamden Arts Commission.)

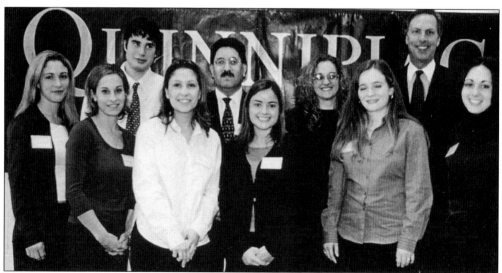

This is a photograph of Hamden recipients of Quinnipiac University scholarships for the 1999–2000 school year. From left to right are Amy Cofrancesco, Rebecca Inzero, Joseph Reynolds, Laura Martineau, Mayor Carl Amento, Kimberly Proto, Michelle Bankowski, Dara Arater-Cejas, university president John L. Lahey, and Graxiella Civitillo.

In a collaboration between town and gown, Quinnipiac students specializing in education have the opportunity to gain experience in Hamden schools. Here, Shayna Winsor serves as a student teacher at Hamden's Helen Street School in 1999.

DISCOVER THOUSANDS OF LOCAL HISTORY BOOKS FEATURING MILLIONS OF VINTAGE IMAGES

Arcadia Publishing, the leading local history publisher in the United States, is committed to making history accessible and meaningful through publishing books that celebrate and preserve the heritage of America's people and places.

Find more books like this at
www.arcadiapublishing.com

Search for your hometown history, your old stomping grounds, and even your favorite sports team.

Consistent with our mission to preserve history on a local level, this book was printed in South Carolina on American-made paper and manufactured entirely in the United States. Products carrying the accredited Forest Stewardship Council (FSC) label are printed on 100 percent FSC-certified paper.

MADE IN THE USA